AFTER IMPRESSIONISM

The Impressionists were almost always at the point of disintegrating. There were small warring groups at virtually every moment in the short history of the movement – the urban realists versus the landscape painters, the painters of modern life versus the painters of rural life, the politically active versus the complacent or passive artists, and the list could go on. Indeed, the seeds of discontent were endemic to the Impressionist idea. Even from the beginning, the group functioned as a cooperative rather than as a club, and its only clearly expressed beliefs were in artistic freedom and experimentation.

Therefore, it comes as no surprise that, after the final Impressionist exhibition, of 1886, the movement lacked clear direction. For that reason, the introduction to this volume, devoted to the paintings, drawings, and prints in the collection of The Art Institute of Chicago made by the Impressionists and their followers in the period from 1890 to 1925, is called "After Impressionism." That designation is intentionally bland, a simple translation of the English critic Roger Fry's phrase "Post-Impressionism," invented for an exhibition of modern French painting held in London in 1906. By that date, the original Impressionist movement had become history, the subject of books and articles rather than fervent aesthetic discussion.

The traditional definition of Post-Impressionism is based largely on the assumption that Impressionist painting was a brilliant, but short-lived, experiment in sheerly optical, unintellectual art and that the Post-Impressionists, in reaction, created what they hoped to be a more enduring, meaningful art based not on sensation, but on the thoughts, emotions, and ideas of the artist. This view is both simplistic and misleading.

Impressionism, we now know, contained within it not only its own dissolution, but also many of the major tenets of Post-Impressionism. By the latter part of the 1870s, Claude Monet, Camille Pissarro, and Auguste Renoir had become concerned about the limits of the direct pictorial transcription of reality, and each artist sought a form of synthesis based on a clear study of pictorial compositions, surfaces, and forms. And, the Impressionists included in their exhibitions the work of the young artists who were to become the major figures of Post-Impressionism: Cézanne, Gauguin, Redon, and Seurat.

The artists who followed in the footsteps of the Impressionists had been liberated by their aesthetic forebears from the struggle against official art that had preoccupied the best young French painters of the 1860s and 1870s. Not only had Monet and Renoir returned to the Salons by 1880, but they had also provided an example to younger artists to band together with small dealers, publishers, and patrons to create a private infrastructure for their art.

The Post-Impressionists were impatient with the realism of their predecessors and created works of art that have less to do with reality, however it is defined, than with powerful symbols, evocative color relationships, and rigorously applied rules of composition. Whether it was Odilon Redon's selection of forms from his imagination floating in fields of rich black or vibrant color, Paul Gauguin's exaggeration of colors to the point that they are no longer recognizable as real, or Paul Cézanne's expression of the essence of his subjects through complex compositional manipulations, the aim of the advanced artist after Impressionism was to heighten reaction to the work of art *as* a work of art.

This consciousness of the power of artists to create new visual orders in the exploration of subjective pictorial visions gave birth to a plethora of movements or *isms* – Neo-Impressionism (or its alternative names, Divisionism and Pointillism); Sym-

bolism and the related Cloisonnism and Synthetism; the Nabis fraternity and its offshoot, Intimism. These rose and faded so quickly that, for the most part, they are hard to define. On the other hand, it is not surprising, given the nature of the period, that the key Post-Impressionists worked in physical isolation from one another. Cézanne withdrew to his native Aix-en-Provence, Vincent van Gogh went to Arles, and Gauguin journeyed the farthest, to Tahiti. By the 1880s, even the former Impressionist stalwarts Edgar Degas and Claude Monet were working reclusively in their respective studios in Paris and Giverny.

The period between the Impressionist Exhibition of 1886 and the outbreak of World War I was, in Europe, the great age of artistic groups, clubs, and gatherings. Small exhibitions were held in countless cafés, exhibition halls, and other semi-public places, and small journals and magazines devoted to art and art criticism proliferated at an astounding rate. For that reason, it is virtually impossible to characterize as a single phenomenon the pictorial arts in the years after Impressionism. The period's complexity can be seen in the varying, and often contradictory, approaches taken by the major artists, whether the symbolism of Redon, apparently personal but in fact resonant with collective meanings, or the subtle transcription of domestic interiors by Vuillard; whether the brilliantly colorful and patterned Tahitian landscapes by Gauguin, or the classicizing Impressionism of Cézanne; whether the haunting bourgeois dramas of Munch, or the calligraphic translations of Paris at night by Toulouse-Lautrec. Nonetheless, the artists knew about one another and responded, often in fascinatingly oblique ways, to each other's inventions. Degas, for example, collected works by Cézanne and Gauguin, as well as examples by Ingres and El Greco, during the last decade of the century, and he used aspects of each

artist in ways that are often difficult to recognize.

Who were the major artists after Impressionism? Curiously, several of them were Impressionists themselves. Included in this volume is the late work of Monet and Degas, because they continued to invent new pictorial strategies throughout their lives that were both influenced by and influential upon the younger artists of the period. Other major figures in the movement – Cézanne, Gauguin, Redon – are also featured. Of the younger artists, the most brilliant included Edouard Vuillard, Ker Xavier Roussel, and Henri de Toulouse-Lautrec, each of whom knew one another and spent considerable time together at dinners, concerts, and weekend parties.

Interestingly, more and more foreigners played important roles in French art after Impressionism. This volume includes the work of a Dutchman, van Gogh; a Norwegian, Munch; and two Swiss, Hodler and Vallotton, each of whom painted in France but made important contributions to the art of their own nations.

It might seem perplexing that this volume of painting after Impressionism should end with the late water landscapes by the archetypal Impressionist, Claude Monet. He was sixty years old at the turn of the new century, and he worked actively until his death, at the age of eighty-six, in 1926. There is little doubt that his late work was as innovative as the art of younger artists who were then making their own aesthetic revolutions: Picasso, Braque, Léger, Matisse.

The collection of European art after Impressionism at The Art Institute of Chicago is truly staggering. It dates back to the 1920s, when Joseph Winterbotham established a fund for the purchase of modern art, and when the Helen Birch Bartlett Memorial Collection was presented to the

museum with major examples by van Gogh, Gauguin, Hodler, Toulouse-Lautrec, and Cézanne. Gradually, other superb works entered the museum's collections, mostly through the generosity of donors such as Annie Swann Coburn and Martin A. Ryerson. Indeed, the importance of the Art Institute's Post-Impressionist collections reflects the taste not just of the museum but of its city.

Only in the area of the graphic arts did the Art Institute staff itself make the acquisitions that have established the Art Institute as one of the world's greatest collections of works on paper by the generation after the Impressionists. The museum's holdings in this area were begun, spectacularly, in 1922, with Redon's own collections of his prints purchased from his widow. This acquisition, in combination with subsequent gifts, including a large group of *noirs,* or black chalk and charcoal drawings, gives the Art Institute the most important collection in the world of the graphic art of Redon. Yet, its preeminence does not stop here, for the Art Institute also has virtually the greatest collections in America of the prints of Munch and Toulouse-Lautrec, as well as of the prints and drawings of Gauguin. These latter collections were assembled not by private individuals in Chicago (although many of the Munch prints came from the private collection of the noted architect Mies van der Rohe), but by shrewd and persistent curators of the Department of Prints and Drawings in the Art Institute: first Carl Schniewind and then Harold Joachim.

Yet, these definitive, specific collections do not overshadow the general excellence of the museum's holdings. The Art Institute has superb watercolors by Cézanne, wonderful drawings by van Gogh, an almost unmatched collection of works on paper by Vuillard, and masterful prints and drawings by other artists around them. This is true as well for paintings: the Art Institute boasts a small, but choice, group of paintings by van Gogh from all but the last year of his life, fine works by Vallotton, and a good selection of paintings by Cézanne that includes several masterpieces.

Needless to say, a book of this type can only represent the highlights of a collection like the Art Institute's, with many beautiful or interesting works of art in all mediums having been omitted for reasons of space. The museum's holdings from this vital period in the history of art are extensive enough to allow the masterpieces to be understood within the large and complex contexts in which they were created. For that reason, a visitor to the galleries and study areas of The Art Institute of Chicago can learn more about art after Impressionism with every visit.

Richard R. Brettell
Searle Curator of European Painting
The Art Institute of Chicago

Post-Impressionists

Richard R. Brettell

The Art Institute of Chicago
and Harry N. Abrams, Inc., Publishers, New York

Executive Director of Publications, The Art Institute of Chicago:
Susan F. Rossen
Edited by Susan F. Rossen and Lyn DelliQuadri

Designed by Lynn Martin, Chicago
Typeset in Berkeley by Paul Baker Typography, Inc., Evanston, Illinois
Printed and bound in Italy by Arti Grafiche Amilcare Pizzi, S.p.A., Milan

Photography credits: Principal photography by Terry Shank, Department
of Photographic Services, The Art Institute of Chicago, with additional
photography by Jaroslaw Kobylecky and Kathleen Culbert-Aguilar.

Back cover: *At the Moulin Rouge*, c. 1894/95, by Henri de Toulouse-Lautrec
Front cover: Detail of *At the Moulin Rouge*

Library of Congress Cataloging-in-Publication Data

Art Institute of Chicago.
 Post-impressionists.

 1. Post-impressionism – Europe – Catalogs. 2. Painting, European –
Catalogs. 3. Painting, Modern – 19th century – Europe – Catalogs.
4. Painting, Modern – 20th century – Europe – Catalogs. 5. Painting –
Illinois – Chicago – Catalogs. 6. Art Institute of Chicago – Catalogs.
I. Brettell, Richard R. II. Title.
ND192.P6B7 1987 760'.09'0346074017311 86-73028
ISBN 0-8109-1494-8
ISBN 0-8109-2352-1 (pbk.)

Post-Impressionists

Vincent van Gogh
Self-Portrait
c. 1886/87

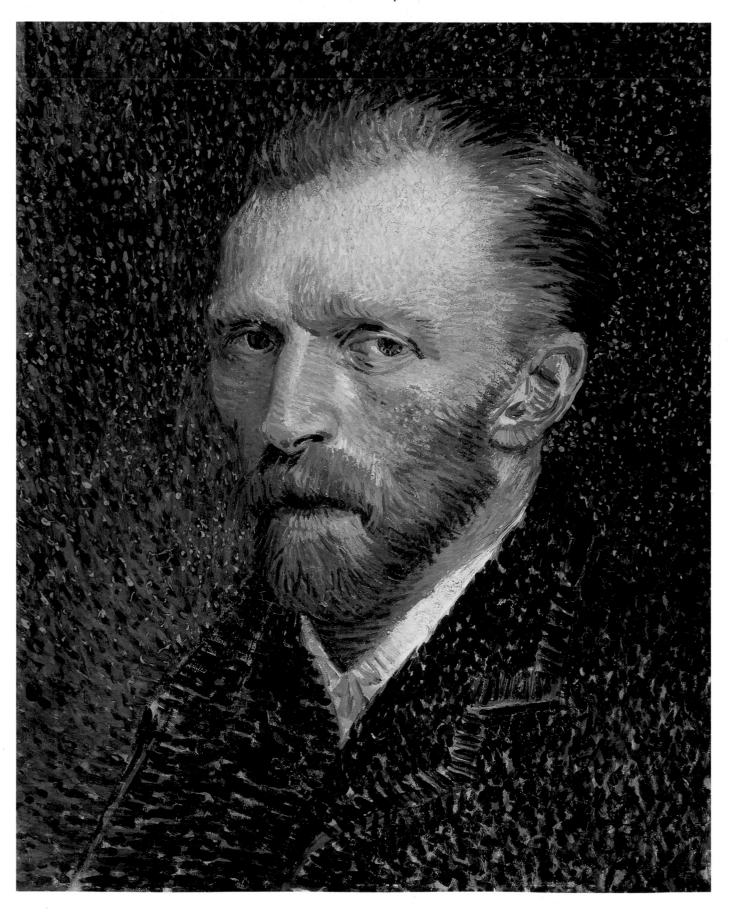

Vincent van Gogh came to Paris for the first time in February 1886. His work up to that point had culminated in *The Potato Eaters*, in which deep, somber colors were applied with an aggressive crudeness appropriate to the rough peasant life that van Gogh chose as his subject. This earthy, rural style had no place in the light, bright, and energetic city of Paris. Always responsive to the character of the place in which he worked, van Gogh fully embraced the new painting styles he was exposed to and proceeded to alter everything about his art. His palette brightened; his subjects became urban and suburban. He nonetheless continued to infuse his work – no matter what the subject – with his own psychological presence. Nowhere is this so directly seen as in the extraordinary series of self-portraits he did during this period: at least twenty-four were painted in Paris between his arrival there and his departure for Arles almost exactly two years later.

Unlike the majority of van Gogh's self-portraits, the Art Institute's was painted on flat pasteboard rather than on canvas, which allowed for greater emphasis on the texture of the painted surface. Like most of the early self-portraits, this one is small, focusing on the head and eyes of the painter rather than on the conventional interplay between face and hands. His deep green eyes seem to send forth halos of red and red-orange that constitute the painter's eyelids. The surface of the painting dances with dots and dashes of color, some of which curve or angle to define the three-dimensional forms of the brow, nose, and beard. The area around the head, which traditionally serves as a background in European portraits, seems alive with molecular particles of color: intense green, blue, red, and orange. This aspect of the painting has often been compared to the Neo-Impressionist "dot" technique of Georges Seurat, whose masterpiece, *Sunday Afternoon on the Island of La Grande Jatte*, in The Art Institute of Chicago, van Gogh saw at the 1886 Impressionist exhibition.

Seurat and van Gogh became close friends in 1887. While this seems a strange pairing – van Gogh, the emotional, unkempt Dutchman; and Seurat, the fastidious, cerebral Parisian – their friendship reveals, beneath their differences, deep affinities of character and aesthetic. Van Gogh had been described as a madman even in the years before his first emotional crisis, in December 1888. Yet, his letters and works of art give structure and clarity to the world they describe. Seurat's art simultaneously contains and masks the sexual and emotional tensions of his own life. While van Gogh adopted Neo-Impressionist techniques to bring order and control to his art, his emotional intensity and seriousness are heightened in this portrait by the dense fabric of palpitating dots of color that surround and define him.

Henri de Toulouse-Lautrec
Portrait of Jeanne Wenz
1886

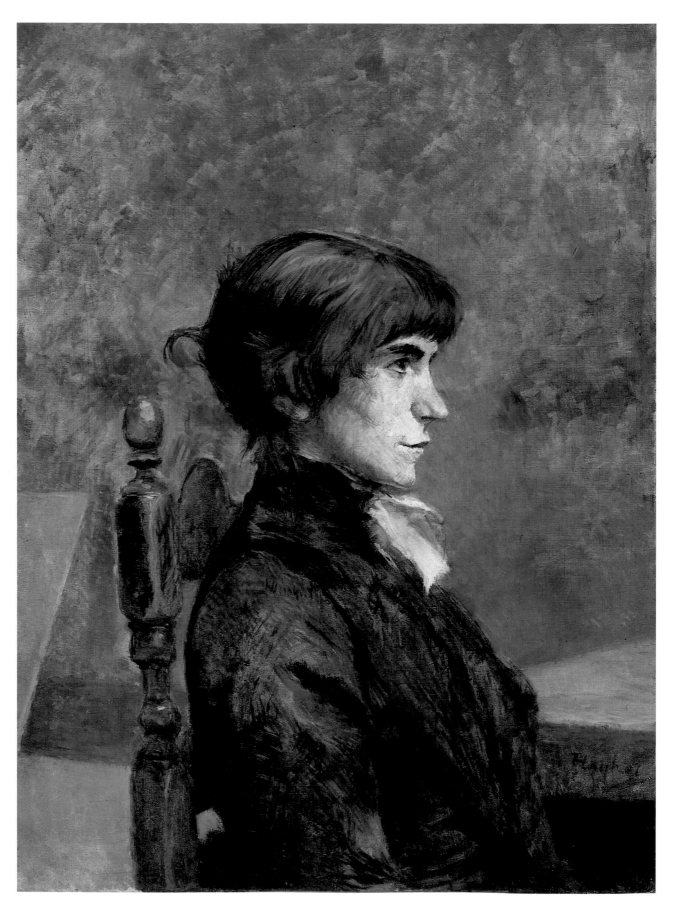

Henri de Toulouse-Lautrec painted this portrait in 1886, probably after the final Impressionist exhibition. Rather than following the advanced stylistic and iconographic trends of Georges Seurat and the painters of the Neo-Impressionist group which dominated that exhibition, the twenty-two-year-old artist chose instead to employ the subtle, grayed palette of Salon painters and the deft brushwork of Auguste Renoir, who had already deserted the Impressionists. The understated result reveals that, in 1886, Toulouse-Lautrec was less interested in making waves than in assimilating pictorial strategies from established artists.

The painting represents Jeanne Wenz, the daughter of a wealthy industrialist from Rheims and sister of Frédéric Wenz, a fellow student of Toulouse-Lautrec's at the studio of the painter Fernand Cormon. A surviving photograph of Jeanne Wenz, once owned by Toulouse-Lautrec, shows a well-dressed young woman in front of a wall covered with a flowered print. How far removed this is from the humble studio interior and plainly dressed sitter seen in the Art Institute's portrait. In the painting, Jeanne Wenz sits dutifully in a common chair, the simplicity of costume and setting, together with the discreet profile pose, emphasizing the delicacy and modesty of her character.

This painting has been linked with the strict profile portraits that were so important in the Renaissance and that we know Toulouse-Lautrec admired for their abstract flatness and elegance. It seems more likely, however, that the artist's profile representations of various sitters, along with the frontal and three-quarter images one also finds in his oeuvre, must be considered as part of a series of investigations of the human figure from many angles and in many attitudes. With her sharply pointed nose and chin, Jeanne Wenz had a wonderfully active profile, which Toulouse-Lautrec echoed in the strong curve of her thick eyebrows, the stray lock of hair at the back of her head, the jaunty bow at her neck, and the playful shapes of the ladder-back chair. In this carefully controlled portrait, the artist avoided severity by including such details as the diagonal baseboard and the corner of a canvas leaning on the wall to the left of the sitter, relieving the strict verticality of the figure and chair she sits in. All these errant curves and subtle manipulations give character to this portrait of a young woman wearing a pink satin bow.

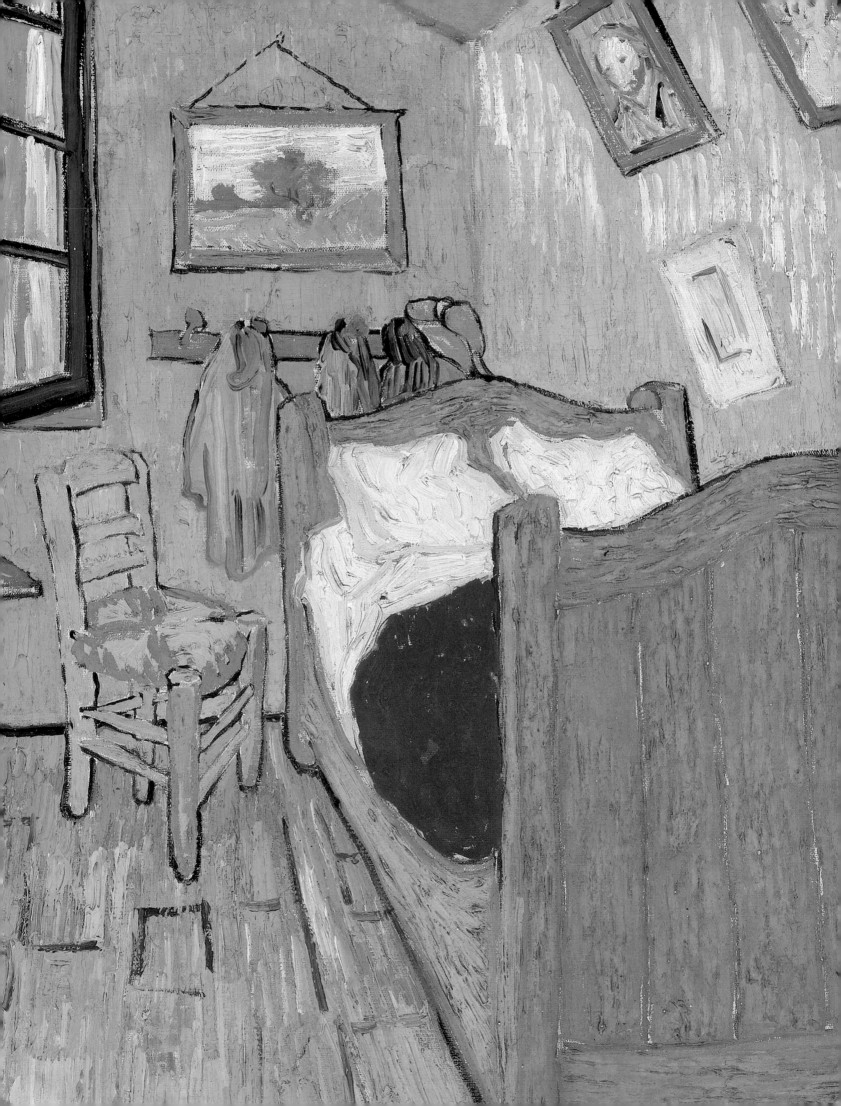

VAN GOGH AND GAUGUIN IN ARLES

Vincent van Gogh journeyed to Arles in February 1888 with the expressed desire to create a new colony of artists in the temperate climate of southern France. In the summer of 1888, he secured a small house on the outskirts of the city and just across from the public garden. His letters are filled with descriptions of domestic activity, as he bought furniture and utensils and made decorations for what he called "The Studio of the South." Always his aim was to share his life with others, and he constantly exhorted his brother, Theo, as well as his friends Paul Gauguin and Emile Bernard to join him in Arles.

Bedroom at Arles, made in the months immediately prior to the arrival of Gauguin in Arles, was part of van Gogh's scheme to decorate the walls of his home and studio. He painted great bunches of sunflowers, portraits of his friends, views of the public garden, and other Arlesian scenes to please the ever-critical Gauguin. Yet, it was van Gogh's *Bedroom at Arles* that most moved Gauguin when he saw it shortly after its completion in October 1888. Van Gogh had painted it after a period of nervous collapse and exhaustion from overwork, and to him it represented "inviolable rest" and harmony.

The painting occupies a complex and significant place in the psychological history of the artist, since we know that his dreams of creating an enduring art colony in this house were quickly to be dashed. It is, thus, easy to read the "quiet" (a word the artist used to describe his bedroom) here as the calm before the storm. Indeed, the uneasy harmony of the intense palette of colors, the dramatic perspective of the floor and bed, and the very emptiness of the room create a tension at odds with the artist's stated purpose in executing the picture. And yet, what one must remember in considering the *Bedroom* is that, for its maker, art integrated dream and reality. Van Gogh's actual bedroom at Arles was never so clean, or so restful. The painting resembles a miniature room, so real does the furniture seem, so palpable the space. The tactility of the paint allows us to feel in our minds the surface of each object. We revel in the emptiness and warmth of the room, and, like van Gogh, each of us fills it with ourselves and our dreams.

Shortly after the arrival of Gauguin on October 20, van Gogh's work entered a confused, inchoate stage, certainly brought on by Gauguin's response to his art. He was critical of the rapidity with which van Gogh worked and with what he considered to be the younger artist's sloppiness and his overdependence on nature. Gauguin himself painted slowly and deliberately, thinking through each portion of his compositions and reworking them until he achieved a total pictorial harmony. Gauguin's considered methods and desire for pictorial unity and symbolic content are everywhere apparent in *Old Women of Arles*. Here, Gauguin created a world in which everything is flat and ambiguous. Did he intend us to know that the yellow pyramids to the right of the old women are straw coverings to protect delicate plants in the chilly autumn weather? Why do the women cover their mouths and look away from the viewer? Is the face hidden in the large bush to the lower left something Gauguin intended to include, and, if so, why? What is the ultimate purpose of the two pictorial barriers – the shrub and the gate – that separate the inside of the garden from the world of the viewer? These and many other questions tumble forth as one absorbs this masterpiece from Arles. It has been suggested that Gauguin did this painting in reaction

to van Gogh's many representations of the public garden of Arles (see p. 21) to demonstrate the evocative power and complex associations with which he could infuse a theme by working from the depths of his imagination. As he stated, "The women here, with their elegant headdresses, have a Greek beauty; their shawls create folds like primitive paintings and make them look like a Greek procession." For all its deliberateness and care of composition, *Old Women of Arles* is much more mysterious and ultimately disturbing than any picture painted in Arles by van Gogh.

After van Gogh's tragic self-mutilation on December 24, he was placed under the care of a physician in the large public hospital in Arles, where he painted several versions of his famous canvas *The Cradler (La Berceuse)*. It represents Madame Roulin, the wife of the artist's friend the postman, but the painting was never intended to function strictly as a portrait. Van Gogh himself called the picture *La Berceuse* shortly after it was finished and during the period in which he made the four surviving replicas of it. The Chicago canvas is undoubtedly one of those replicas. Van Gogh wished to hang all the versions together and in combination with his Sunflower canvases to create a composite decoration whose subject was consolation and joy. The many passages in his letters referring to *La Berceuse* suggest that he conceived of the pictures as allegories of motherhood. In one, he spoke of the fact that he intended the painting for sailors at sea – "sailors, who are at once children and martyrs, seeing it in the cabin of their boat should feel the old sense of cradling come over them and remember their own lullabies." When considered in this way, the boat in which the sailors toss and turn becomes a cradle moved not by the sea, but by their mothers. When one remembers that van Gogh himself was alone in what was for him a foreign hospital, far from his family, the fact that he replicated this soothing image four times is scarcely surprising.

Vincent van Gogh
The Cradler (La Berceuse)
1889

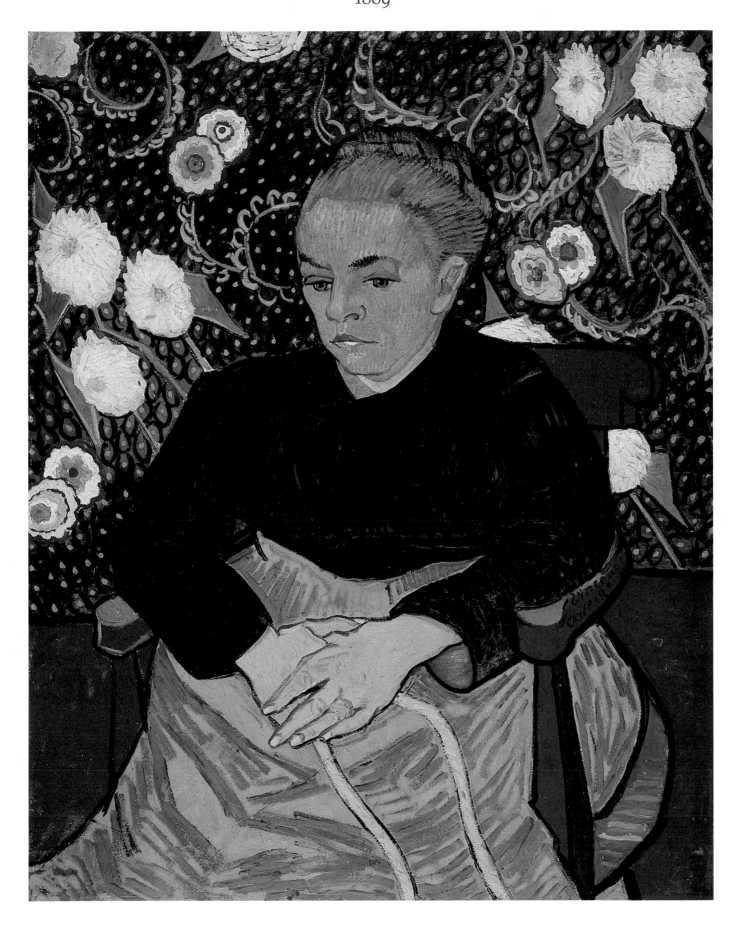

Vincent van Gogh
Bedroom at Arles
1888

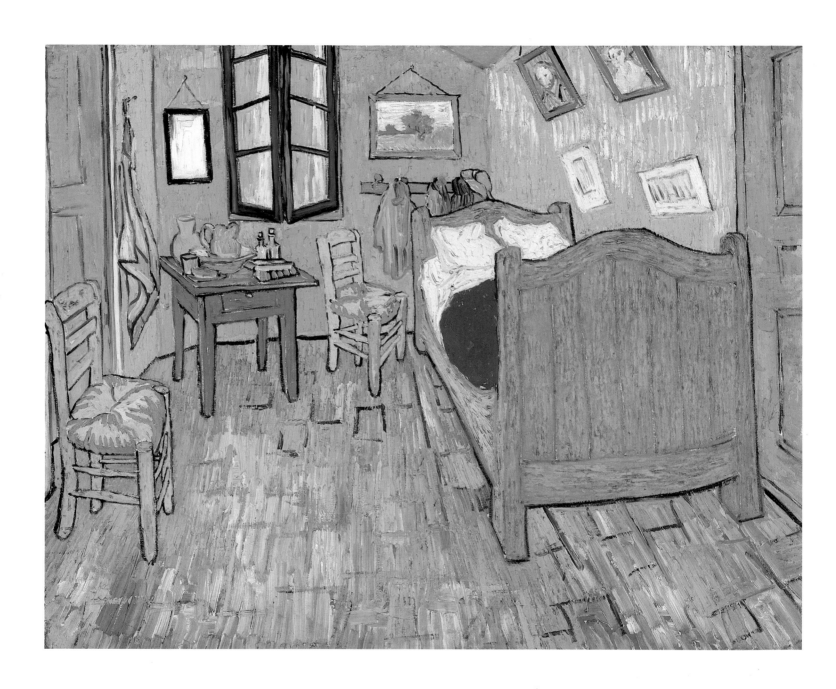

Paul Gauguin
Old Women of Arles
1888

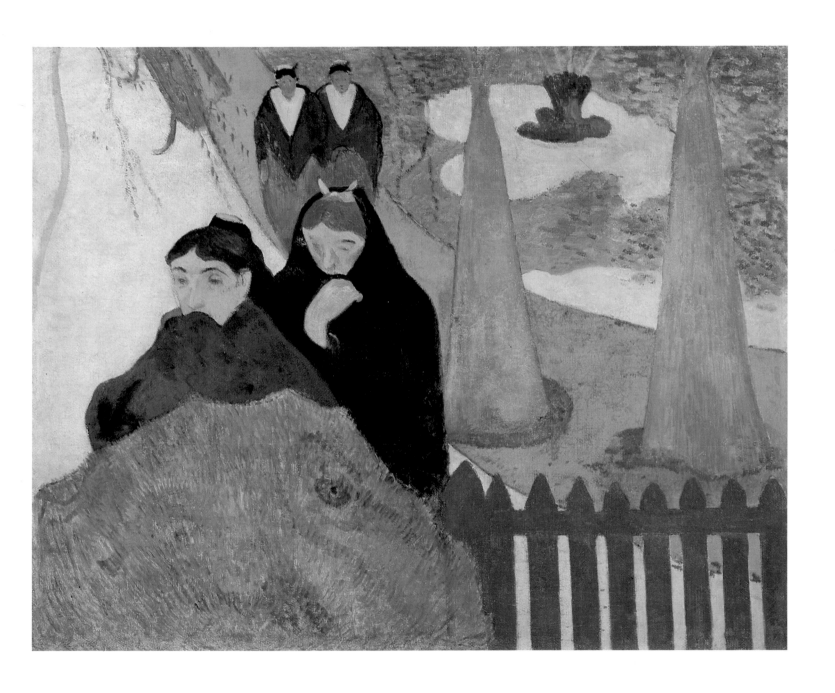

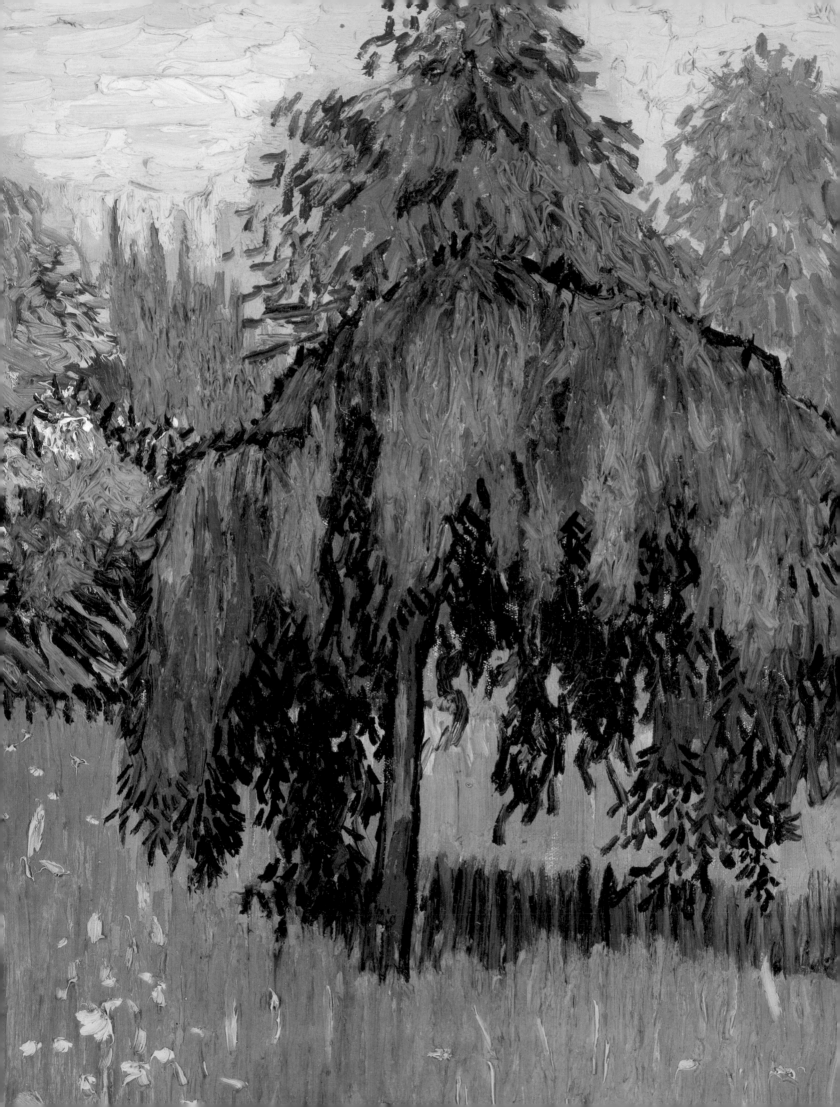

VAN GOGH'S EARTHLY PARADISE

Across the street from Vincent van Gogh's "Studio of the South" was a small, walled public garden that served as a kind of paradise for the deeply troubled artist. Its gently curving paths, reflecting pools, gnarled trees, and blooming plants fascinated him, and he drew and painted the garden in a series of works that are among the finest of his Arles period.

The artist's letters from Arles mention the garden paintings in conjunction with meditations on the walks of the great Italian Renaissance poet Petrarch through the gardens of Provence over four-hundred years before. When he drew and painted the modern public garden in Arles, the painter recalled Petrarch's love of the plants in nearby Avignon. The painting called *Garden of the Poets* most probably hung in a walnut frame in the corner bedroom that van Gogh decorated for Paul Gauguin, which over-looked the public garden represented in the painting. Van Gogh adorned his friend's room with four paintings of the public garden in different light and in different moods. For van Gogh, the public garden was a place of release, where the imagination was freed by the light of day. Even the rhythms of the trees and shrubs were, for the artist, absolutely alive, as he wrote, "their green... continually renewing itself in fresh, strong shoots, apparently inexhaustibly."

Of all the painted versions of the public garden, *Garden of the Poets* is the most intensely green, the most devoted to the imagery of growth so evident in the painter's prose. Absent from this painting are the paths and little benches that domesticate other painted views of the park. Here, the plants dominate, and the frantic tangle of their growth is encouraged by the intense, almost artificial, light of the citrus-yellow sky, tinged with the same green as the plants themselves. The one hint of the city in the midst of which this garden stood is the bell tower of the church of Saint Trophime, painted in brilliant blue and seen through the foliage at the left of the composition. Given van Gogh's spirituality, this detail too is symbolic, like the yellow of the sky and the green of the grass and trees.

In a letter of 1889, van Gogh called his drawings of the public garden at Arles "hasty studies made in the garden," but the Art Institute's sheet, *Corner of the Public Garden in Arles*, repays hours of careful study. Van Gogh evidently began the drawing by composing the major forms on the sheet with the light touch of charcoal. After the composition was established, he changed mediums, taking up a reed pen and black ink to give the scene rigor and linear character. The focus of the drawing is a small tree whose twisted branches seem to have been trained into artificial rhythms by careful pruning. The branches gesture with such pulsing vitality that they almost become the veins and arteries of the composition, charging it with life.

Unfortunately, the inks used have faded gradually from an intense black to brown and even to pale beige. This sheet, however, has been shielded from damaging rays of light and preserves today the strength that it had when it was made. It is no accident that the Dutch artist chose to work so often with the reed pen, a technique immortalized two centuries earlier by the greatest artist in the history of Holland, Rembrandt van Rijn. The reed pen is the most natural and primitive of graphic tools, and van Gogh, like his seventeenth-century mentor, jabbed at the paper with an incredible vigor. Perhaps because the flow of ink in a reed pen is so difficult to predict and, hence, control, the gestures it records are strong, short bursts of graphic energy. How appropriate they are to an image of growth.

Vincent van Gogh
Corner of the Public Garden in Arles
1888

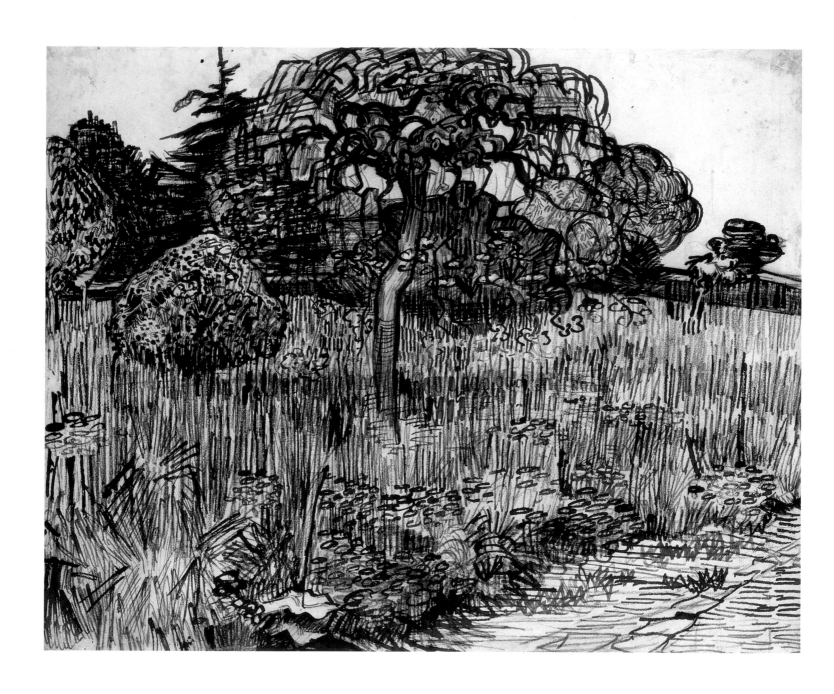

Vincent van Gogh
Garden of the Poets
1888

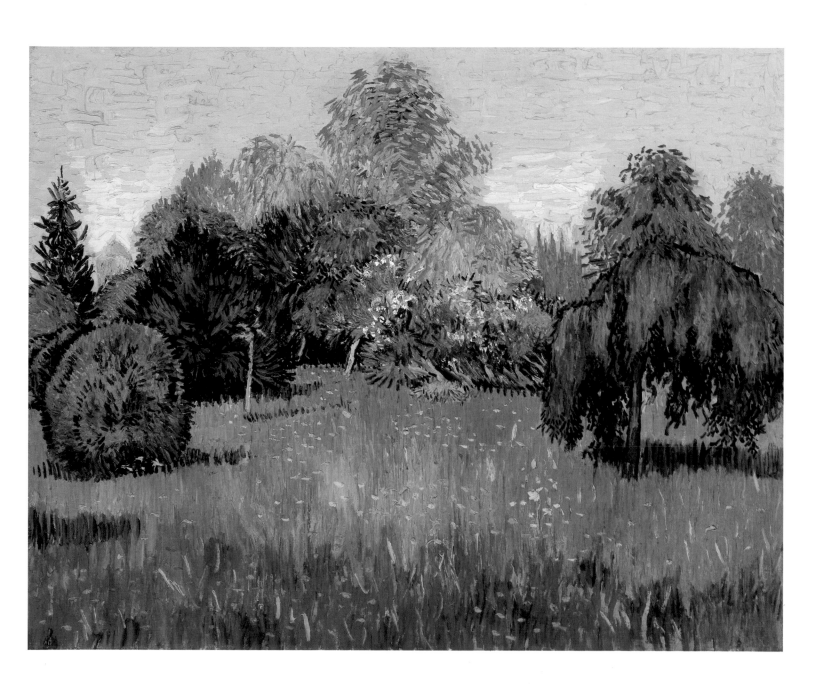

James Ensor
Still Life with Fish and Shells
1888

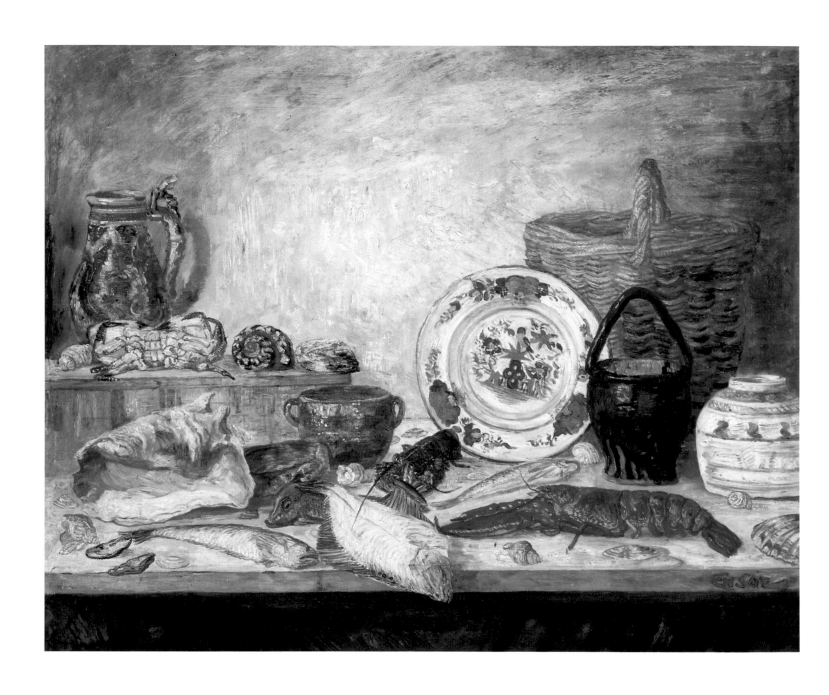

The Belgian artist James Ensor was among the most enigmatic artists of his time. The son of middle-class merchants in the sea-resort community of Ostend, he was encouraged to become an artist by his parents and protected by them from the economic pressures of such a life. In this supportive environment, he developed an utterly personal, Symbolist art that was appreciated for many years by only a few critics, artists, and patrons. He showed his work with various avant-garde groups, most notably Les Vingt, the Belgian organization whose exhibitions were the most daring in Europe in the late 1880s. Ensor's masterpieces from the 1880s come less from visual reality than from the artist's fertile imagination. They describe a world of fantasy, fear, and violence; and they are painted in vivid colors with a directness and emotionality that rival the art of Vincent van Gogh. Yet, where van Gogh's symbols are to be found in the real world, those of Ensor rarely are. In Ensor's paintings, faces are replaced by masks, bodies by skeletons.

The black comedy and fierce social satire of Ensor's most characteristic paintings can be contrasted with his still lifes. His still lifes from the early 1880s were painted in a dark, heavy manner that derived from earlier Dutch prototypes. However, by 1887, Ensor's still lifes became lighter, brighter, and more bizarre in their subjects. Inspired by the tradition of marine still lifes in seventeenth-century Northern art, *Still Life with Fish and Shells* is an accomplished, highly finished painting. Ensor seems to have been particularly interested here in shiny, hard objects – animate and inanimate – whose iridescent, pearly hues he could explore with scumbled, bravura brushwork more at home in the twentieth century than in the nineteenth. Each form has been singled out for intense individual analysis so that its uniqueness is stressed more than its participation in the larger, fictive world of the painting. There is something unsettling, even creepy, about this arrangement. One cannot imagine that any of the unappetizing, even ugly, selection of fish will be cooked or served in the assortment of baskets, bowls, pitchers, and plates displayed on the serving board.

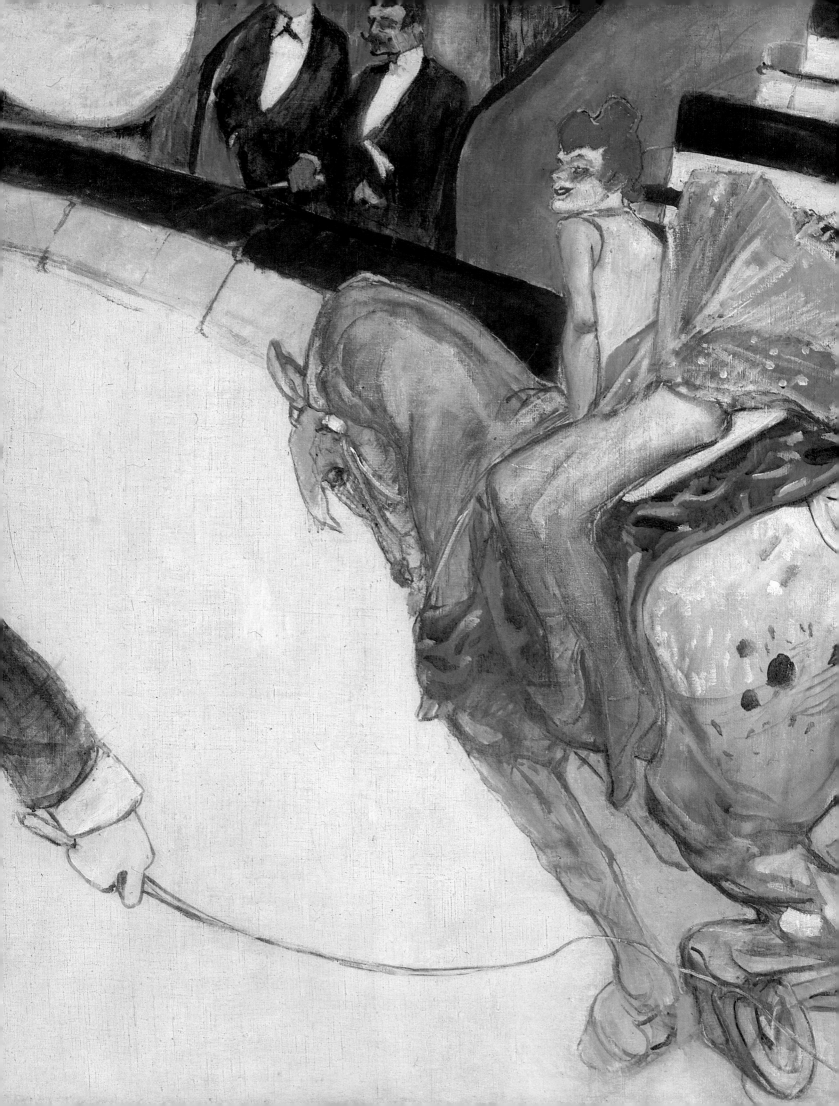

TOULOUSE-LAUTREC'S URBAN WORLD

In the Circus Fernando: The Ringmaster is Henri de Toulouse-Lautrec's first major work. Probably begun in 1887, it was finished by 1888 and exhibited in the lobby of the famous night club the Moulin Rouge (see p. 44). It both predates and prefigures Georges Seurat's 1890 masterpiece *Le Cirque* (Musée d'Orsay, Paris); and its rhythmic contours, staining technique, and boldly graphic composition anticipate later works by artists as diverse as Edvard Munch and Pierre Bonnard. Toulouse-Lautrec himself learned many lessons in this painting, lessons he later applied to his now world-famous posters, as well as to the circus drawings he made while confined to a mental hospital at the end of his life.

The artist who made this painting was full of confidence, energy, and wit. He chose as his subject the well known Circus Fernando, which both Renoir and Degas had already painted and which was to remain a major subject of French painters from Seurat to Léger. By the late nineteenth century, circuses had increasingly come to be permanent attractions, housed in buildings designed specifically for them. The Circus Fernando was the first such circus constructed in Paris.

In Toulouse-Lautrec's painting, an exotically dressed, red-headed woman rides a large, gray stallion and two clowns perform tricks. The woman's eyes turn directly to the ringmaster, whose aggressive, cruel face regards her without remorse as he whips the horse forward. Whether or not her plight is contrived as part of the show, it is made all the more rivetting because the spectators included in the painting pay no attention to her.

It is the simultaneity of activities that makes the picture so modern. Rather than focusing our attention on a single, central motif, Toulouse-Lautrec energized the peripheral events. One clown almost disappears off the left edge of the canvas, and the lower half of another seems to have dropped in from the top. The center of the picture is a void whose emptiness is charged by the cracking of a whip.

Moulin de la Galette was very likely made with Renoir's *Ball at the Moulin de la Galette* (Musée d'Orsay, Paris) of 1876 in mind. In the 1870s, when Renoir went to the famous entertainment hall at the top of Montmartre, it was a thriving, open-air café-concert where one spent weekend days drinking mulled wine or beer, chatting, and dancing. By 1889, the Moulin de la Galette had declined in popularity, supplanted by evening café-concerts such as the Moulin Rouge.

Toulouse-Lautrec's painting takes us far from the sunlit, innocent world of Renoir. Against a backdrop of dancers, interpreted in caricaturelike fashion, sit four figures. The most beautiful is the young woman at the lower left who turns away from the dance floor to look at something or someone outside of the picture. She is, in many ways, an archetypal woman of the *fin de siècle*, a distant muse lost in her own thoughts. Her superb profile almost glows, expressing her vulnerability in the raucous, almost vulgar, public setting.

The two other women, one older and the other thinner than the first woman, sit passively, waiting to be asked to dance. The single man behind them seems unaware of their presence. He extends his body over the railing as he looks intently beyond the picture plane, counteracting the gaze of the beautiful woman in the opposite direction. In this way, Toulouse-Lautrec suggests the ultimate isolation of urban dwellers like these, as well as the futility of their hopes and permanence of their loneliness.

Detail of
In the Circus Fernando:
The Ringmaster

Henri de Toulouse-Lautrec
In the Circus Fernando: The Ringmaster
1887-88

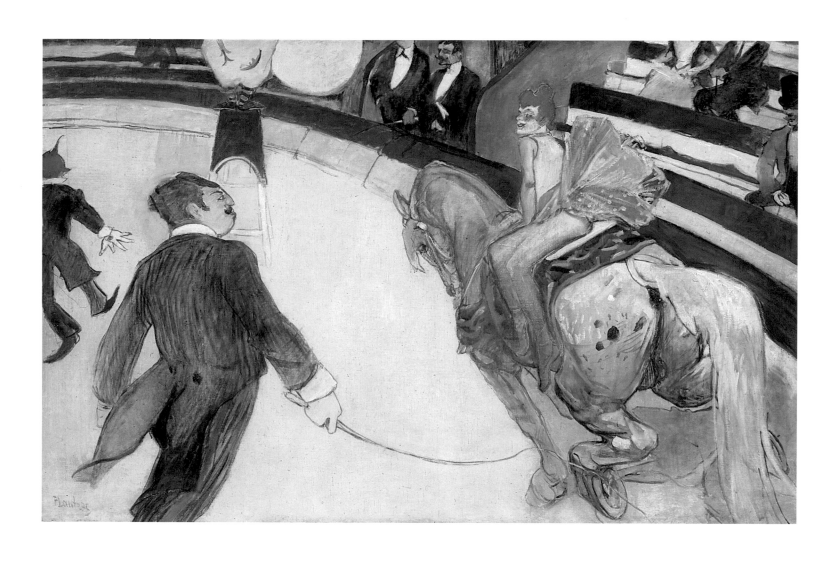

Henri de Toulouse-Lautrec
Moulin de la Galette
1889

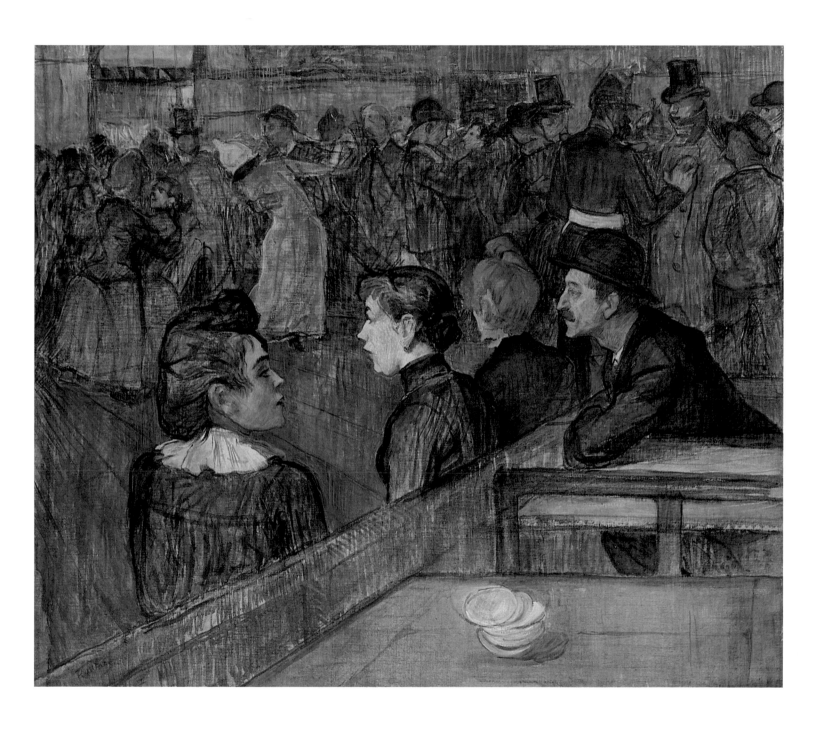

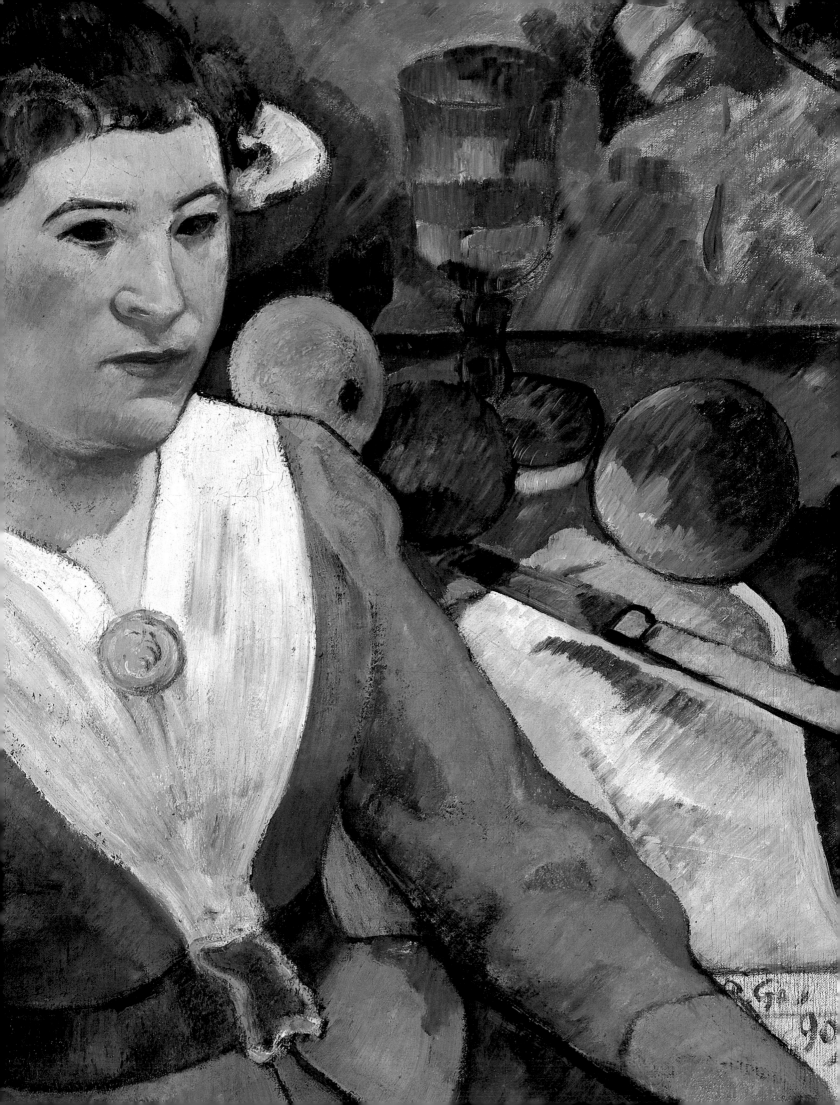

GAUGUIN'S HOMAGE TO CEZANNE

Paul Gauguin's first visit to Brittany was made in the summer of 1886, shortly after the final Impressionist exhibition, in which Georges Seurat had stunned Paris with his *Sunday Afternoon on the Island of La Grande Jatte* (The Art Institute of Chicago). Gauguin was less successful than Seurat in drawing attention to his work. It was partly this failure that prompted the former banker to leave Paris for the remote region of Brittany, which, with its own language and culture, was the least French, and most primitive, section of northern France. Its craggy coast, desolate villages, and relatively inexpensive living attracted Gauguin, along with many other artists before him, and allowed him to escape the many pressures and disappointments of artistic life in Paris.

At the same time that the nomadic artist yearned for exotic, far-flung places, he was a restlessly social being who preferred to surround himself with a bevy of admirers and followers, most of whom he ruthlessly dominated. In Brittany, he met several young painters, including the gifted young artist Emile Bernard, whose informed and highly symbolic art exerted a powerful influence over Gauguin. Quickly assuming the leadership of the group, the older artist moved in his art toward greater simplification and abstraction of color, line, and form, in order to explore the mysteries, superstitions, and emotions that he believed underlie appearances. The style Gauguin and his protégés evolved in Brittany, variously called Cloisonism and Synthetism, placed them directly within the Symbolist movement then current in Paris.

While he exhorted his entourage to shun the tenets of realism and to turn instead for inspiration to examples of ancient, medieval, non-Western, and even children's art, Gauguin did encourage the study of certain contemporaries. He was very drawn to the art of Paul Cézanne. As one of his disciples, Maurice Denis, recalled: "[Gauguin's] superiority consisted in furnishing us with one or two very simple and obviously true ideas at a moment when we were totally lacking instruction. . . . He brought us the art of Cézanne not as the work of a genial independent and of an irregular of the Manet school, but as what it is, namely, the result of a long effort, the necessary consequence of a great crisis."

Gauguin had been introduced to Cézanne, nine years his senior, by Camille Pissarro, who had befriended and counseled both men, and they worked side by side for a brief period in 1881. While still a banker, Gauguin formed a collection of modern art that included several compositions by Cézanne. One of these, entitled *Compote, Glass, and Apple* (private collection, New York), of 1879/80, he did not sell with the rest of his collection when he needed funds, but kept until his death. Its inclusion in the Art Institute's *Portrait of a Woman in Front of a Still Life by Cézanne* is graphic acknowledgment of Gauguin's deep admiration for the Provençal artist. (The still life appears again in Denis's *Homage to Cézanne*, now in the Musée d'Orsay, Paris, attesting to the high regard for it in, at least, Gauguin's immediate circle.)

Portrait of a Woman is virtually unique among the paintings made by Gauguin in Brittany, because there is nothing in the sitter's fashionable dress or the neutral setting to suggest that rustic region. The painting's early history is little known; it was not exhibited until 1911, at the Stafford Gallery in London, when it was called *Portrait of a Girl*. Since then, the composition has been exhibited and published many

times with various titles, but the identity of the beautiful young woman has never been secured.

That we do not know the name of the model is probably an accident of history. The painting has the character of a conventional, three-quarter portrait in an interior, and the head of the sitter is precisely described. She is seated in an upholstered, purple armchair, in front of the prized Cézanne still life. Gauguin's respect for the painting seems to have bordered on reverence; the portion of the still life he included in the Art Institute's portrait is virtually identical to Cézanne's original in its size and surface, except that Gauguin's brushwork is thinner.

While Gauguin painted his replica of *Compote, Glass, and Apples* very directly, he struggled with the figure of the seated woman. X-ray examination indicates clearly that Gauguin adjusted the angle of the chair, the dress, and the position of the woman. At one point, the figure was seated further back in the chair, with both her arms resting on its arms and her hands folded together in a manner in which Cézanne often portrayed his wife (p. 64). Even without this particular reference to Cézanne, the painting does recall portraits of Madame Cézanne in its planar structure, monumentality, simplification of detail, and careful modeling with parallel brushstrokes. And, yet, unlike the still life by Cézanne, the forms of *Portrait of a Woman* are more decorative and fixed as shapes, contained as they are within delineated contours. Gauguin signed the painting on the white, unprimed canvas that, in the picture, represents the plain, white frame surrounding Cézanne's still life. He thereby indicated that his association with Cézanne's painting was stronger than with his own.

Paul Gauguin
Portrait of a Woman
1890

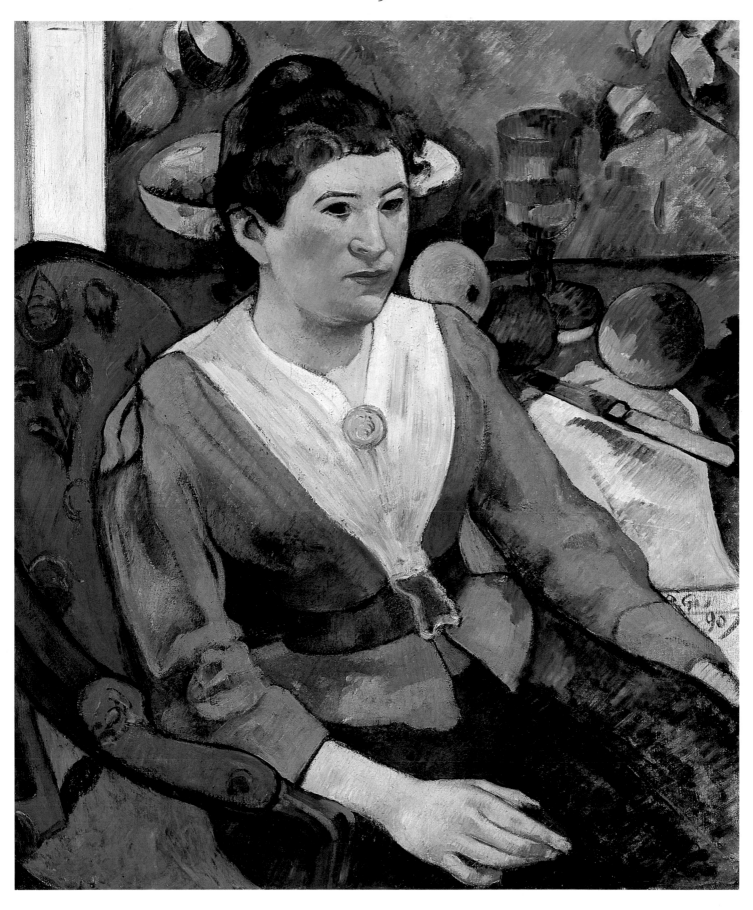

Paul Cézanne
Vase of Tulips
c. 1890/92

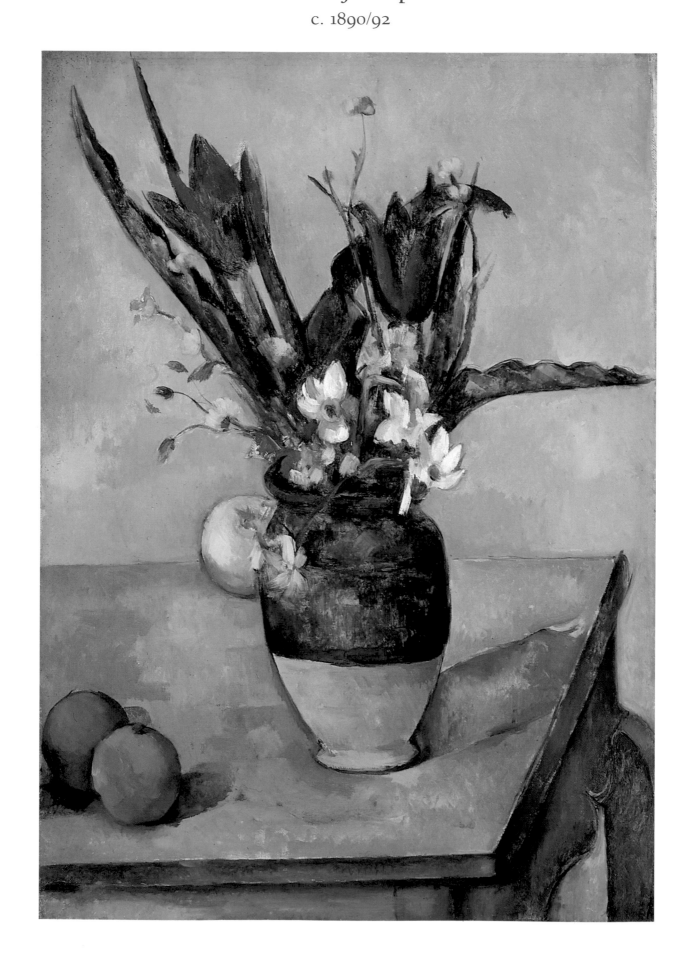

Although Paul Cézanne is considered one of the preeminent still-life painters in the history of Western art, his contribution to the genre of flower painting is neither widely known nor suffi-...ly appreciated. Yet, in spite of their critical neg-... ... were highly re-

half of the composition, while the flowers and greenery compete for attention in the upper half.

Unlike most flower painters in the history of art, Cézanne was not interested in the fragile sensuality of flowers. His choice here of tulips – strong, spiky flowers with hard petals and firm leaves – differentiates this painting from the more sensual or decorative Romantic and Impressionist floral still lifes representing sunflowers, chrysanthemums, daffodils, irises, or dahlias. And, yet, the inclusion of the more fragile buttercups and narcissus not only provides a contrast of color, but also a quality of delicacy and fragility.

Interestingly, Cézanne focused his most concerted attention on the painting of the lower left corner of this composition; even a cursory examination of the surface reveals that he had originally included at least three more pieces of fruit in the void between the vase and the two oranges at the lower left. By omitting these fruits, most of which were retained in the other version of the painting, Cézanne not only simplified but energized the painting.

Printed in the Netherlands

33

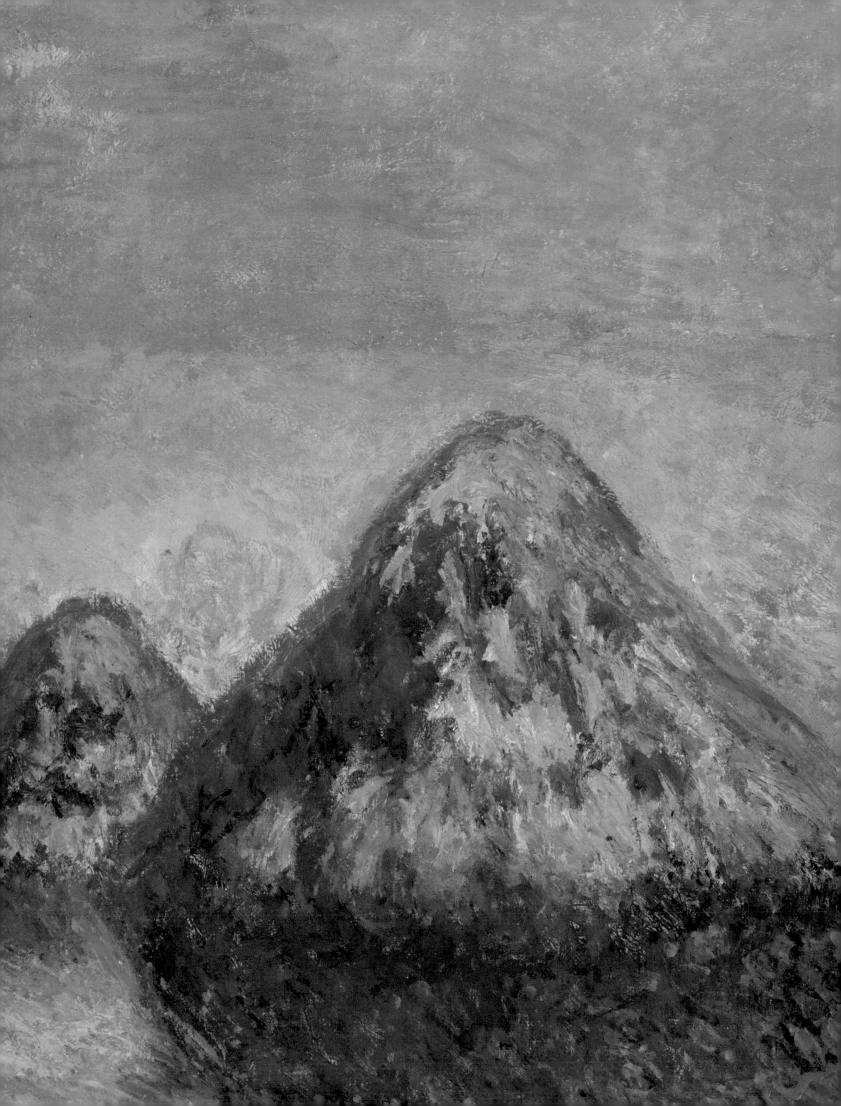

MONET'S HAYSTACKS

On May 4, 1891, an exhibition of recent works by Claude Monet opened at the Durand-Ruel gallery in Paris, including a "Series of Haystacks (1890-1891)," as the pictures were identified in the catalogue. These paintings were an important breakthrough, not only in Monet's career but in the history of French art. Curiously, their novelty was less the result of their style than of their subject matter, and less because the subject was in itself unusual than because each of the fifteen paintings had the same subject, and were intended to be seen together.

It seems amazing that, in 1891, these images of mundane haystacks, with their various seasonal and temporal backgrounds and their scumbled, almost corrugated, facture, were explained by the critics in such evocative, poetic prose. The subject of the paintings was essentially ignored in the various attempts to render into words Monet's pictorial transcriptions of time. For Gustave Geffroy, they represented "the poetry of the universe in the small space of a field... a synthetic summary of the meteors and the elements." And, for Désiré Louis, the viewer was "in the presence of sensations of place and of time in the harmonious and melancholic flow of sunsets, ends of day, and gentle dawns."

Monet's Haystacks could now be seen by his contemporaries as fundamentally anti-naturalist: they were about time and color rather than about the way natural form and light interact. The Haystacks were evocations of nature, a series of works unified by an overall surface and a decorative, thematic harmony. For Monet, the Haystack series provided an opportunity to combine a basic doctrine of Impressionism – capturing what he called "instantaneous" moments in nature's temporal cycles – with the modern notions of painting that sought to extract from and reconstruct nature according to the formal and expressive potential of the picture itself.

Monet's style and subject matter had changed drastically from his early Impressionist days. After moving to rural Giverny in 1883, he began to evolve a landscape imagery that was fundamentally romantic, with picturesque scenes and few, if any, human figures. Unlike the traditional Romantic landscape painters, who tended to paint large, all-encompassing vistas, Monet isolated specific elements of nature for their potential as carriers of various moods or human feelings and not as narrative devices.

For Monet, the haystack was a form full of resonance. Its association of abundance and of man's ability to sustain himself and his animals on the richness of the harvest are obvious and compelling. Surely, Monet, who lived for many years in rural settings, knew the importance of the haystack to his neighbors and, by making them the clear motif in his scenes, allowed their meanings to unfold in a complex succession.

Clearly, it had become impossible for the great landscape painter to compress his many simultaneous sensations and feelings onto a single canvas: he had to work in series in order to convey more clearly and completely the nature of his struggle to master the representation of time. He worked furiously in the last days of spring 1891 to bring a group of fifteen independent canvases into collective harmony. In the end, he succeeded in making something unique – a series of separate paintings that are at once dependent and independent. The individual paintings succeed on certain levels as works of art. However, it is only in creating groups of the pictures that the complexity of Monet's intentions can be understood.

Claude Monet
Haystacks, End of Day, Autumn
1891

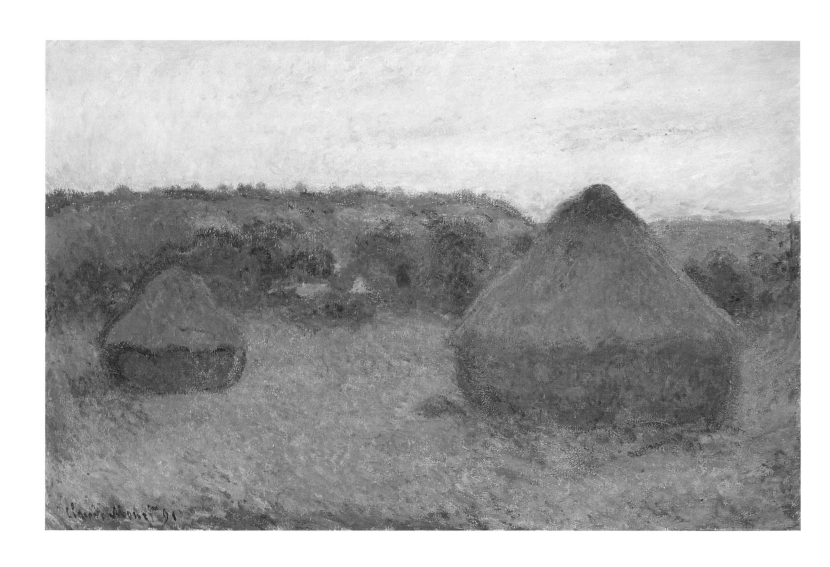

Claude Monet
Haystacks, Setting Sun
1891

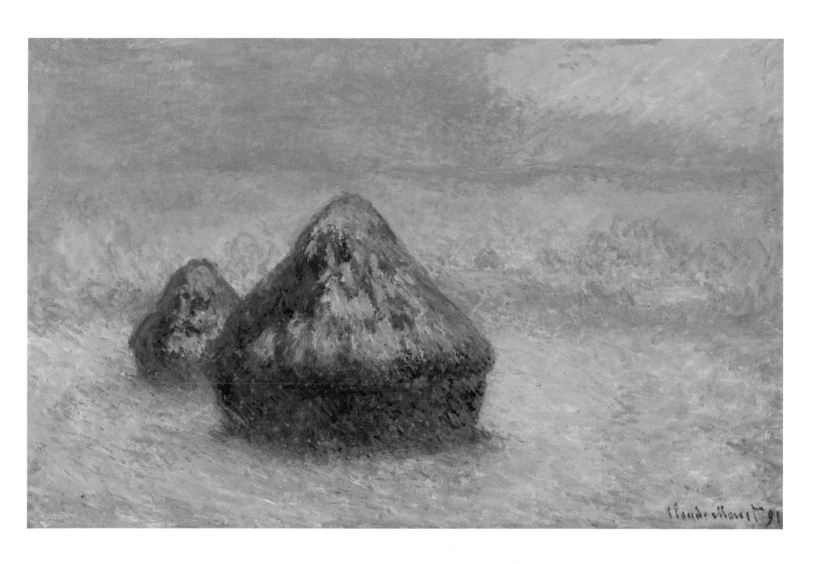

Claude Monet
Haystack, Thaw, Sunset
1891

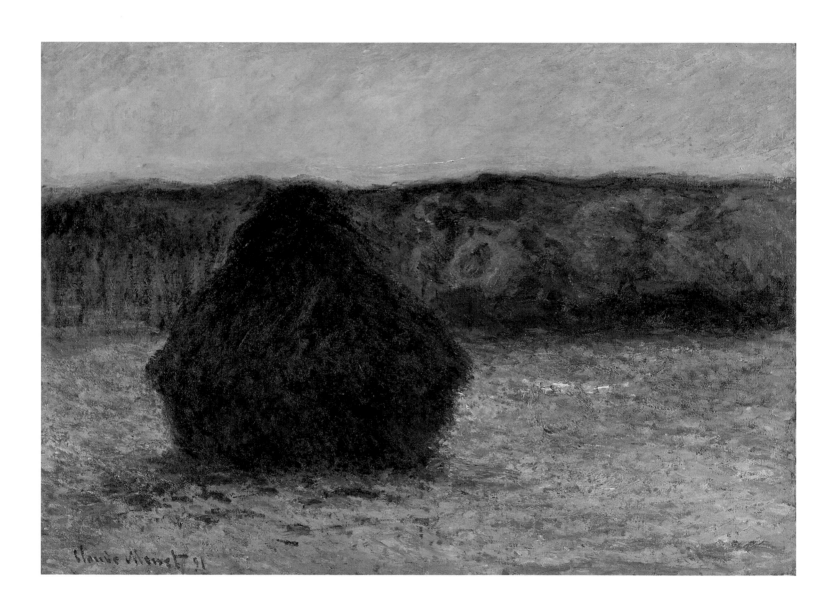

Claude Monet
Haystack
1891

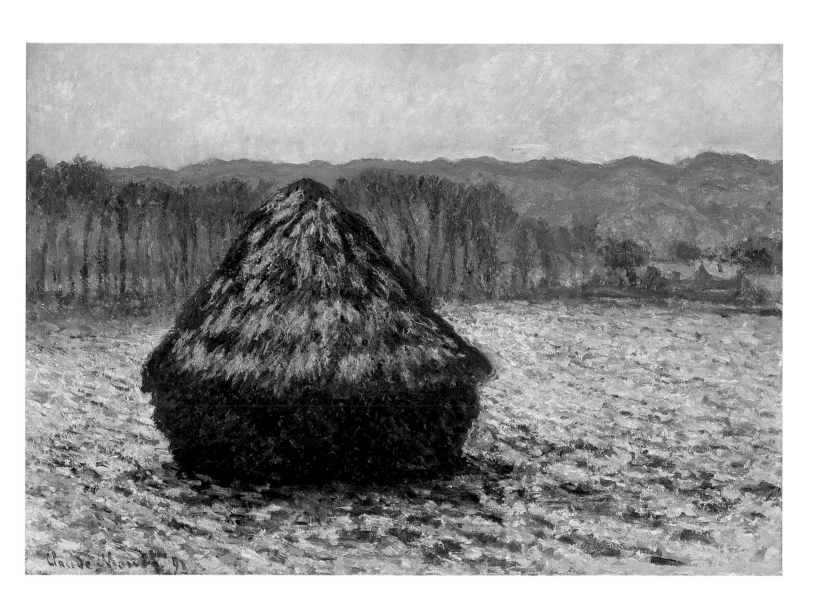

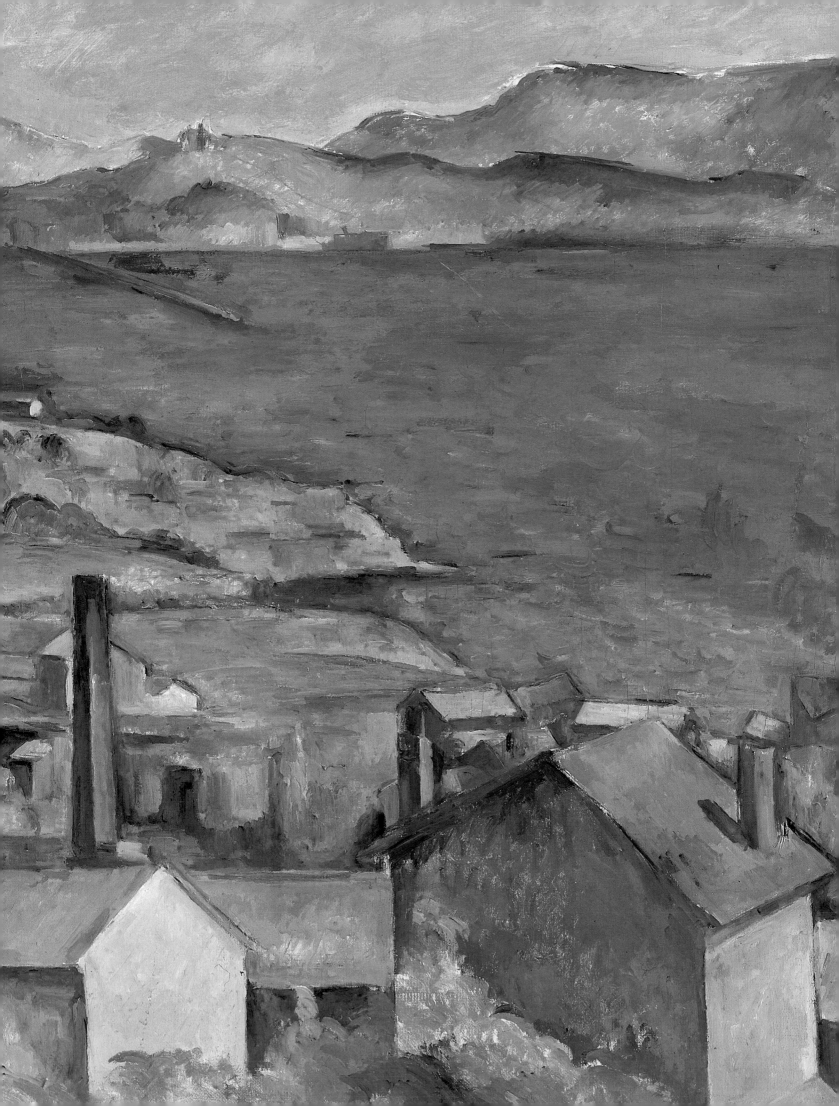

CEZANNE'S ELEMENTAL SEASCAPE

After the severe criticism he received for works exhibited in Paris in 1874 and 1877, Paul Cézanne retreated increasingly in the 1880s from the art capital to his native Provence. While he felt very isolated from the center of avant-garde activity in Paris, he was deeply moved by the "configuration" of his native landscape, rich in ancient history and extraordinary scenery.

In 1870-71, Cézanne made his first extended visit to the tiny coastal village of L'Estaque, about thirty kilometers from his home in Aix-en-Provence, to escape conscription into the French army during the Franco-Prussian War. His mother had a small house there with superb views of Marseilles, its Mediterranean harbor, and the coastal mountains. In 1883, Cézanne rented a house in the village. For the rest of his working life, visits to L'Estaque provided a welcome relief from his ordinary working environments, with both the sea air and superb scenery rejuvenating him many times. The breathtaking views of the bay moved him in particular. He wrote to his friend and teacher Camille Pissarro:

It is like a playing card. Red roofs on the blue sea. The sun is so terrifying that it seems as though the objects are silhouetted, not only in black and white, but in blue, red, brown, and violet. I may be mistaken, but it seems to me the very opposite of modeling.

Convinced that Impressionism was on the wane, Cézanne was searching for a way not to dissolve form and eliminate local color, as he felt Claude Monet had done. To capture the intensely colored rocky terrain, sea, and sky of Provence and, at the same time, suggest the timelessness of the landscape was no easy task, and Cézanne constantly complained about the difficulty of his intentions.

The Art Institute's *Bay of Marseilles* is one of several equally important views of the sea from L'Estaque Cézanne made in the middle and late 1880s. He divided the canvas into four zones – architecture, water, mountain, and sky. Each is rigorously separated from the next and has its own, distinct character. The sky is painted airily, with broad strokes of viscous paint loosely applied over a white ground. The city of Marseilles, its jetty clearly discernible in the background, is reduced to a few rectangular patches of paint along the left side of the mountain range, which gently increases in height from left to right. Although Cézanne lavished his most concentrated pictorial energies on the representation in the foreground of the town, with its cubelike habitations punctuated by chimneys of varying sizes, it is the great blue expanse of the Mediterranean itself that is the true subject of the picture. Filling the center of Cézanne's banded composition, the sea's solidity is profound. No boats are allowed access to its weighty waters, and one can scarcely imagine waves disrupting its dense, planar surface.

All the elements in this landscape – water, sky, land, villages – are motifs found over and over in Impressionist paintings. Like an Impressionist picture, the colors in the *The Bay of Marseilles* are bright, the scene filled with sunshine. Yet, we are worlds away from, for example, Monet's many depictions of the Mediterranean coast at Antibes dating from the same period – in which images of great immediacy and vivacity seem to shimmer in the dappled, fragrant atmosphere. Cézanne was not interested in the illusion of light, or of distance, or of form, for that matter. His comparison of the bay at L'Estaque to a "playing card" is telling; in the Art Institute's canvas, he drew

each plane forward – from the sky and mountains to the sea and village – deliberately contracting the space, an effect heightened by the emphasis on contour. The resulting, highly compacted structure is locked tightly in place, like a puzzle, its parts related through a complex grid of horizontal, vertical, and diagonal lines. As Cézanne wrote the artist Emile Bernard, "Lines parallel to the horizon give breadth. . . . Lines perpendicular to the horizon give depth. But nature for us men is more depth than surface, whence the need of introducing into our light vibrations, represented by reds and yellows, a sufficient amount of blue to give the impression of air." Cézanne's use here of strong, contrasting colors to create a sense of volume and space both strengthens the composition and infuses it with vitality.

If it were to be judged as a successful rendering of water – that is, as a seascape – *The Bay of Marseilles* would fail, just as Cézanne's portraits fail at accuracy of likeness and his bathers fail at sensuality. Cézanne's view of the scenery at L'Estaque is, in the end, elemental and eternal. The painting records an almost existential encounter between art and nature. As is true of any painting by Cézanne, neither the world of appearances nor that of art is allowed to triumph: his images are at once abstract and totally dependent upon visual reality.

Paul Cézanne
The Bay of Marseilles Seen from L'Estaque
c. 1886/90

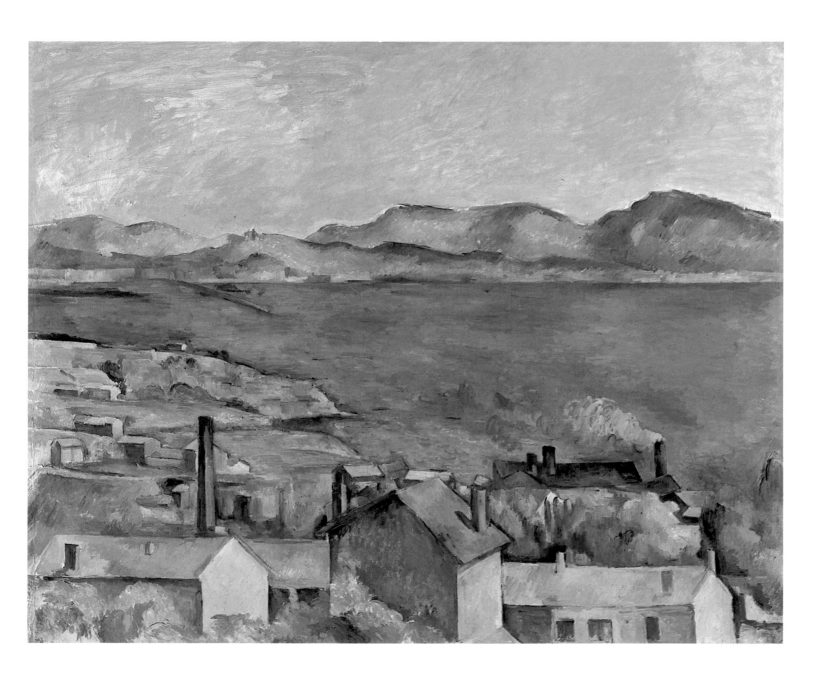

Henri de Toulouse-Lautrec
At the Moulin Rouge
c. 1894/95

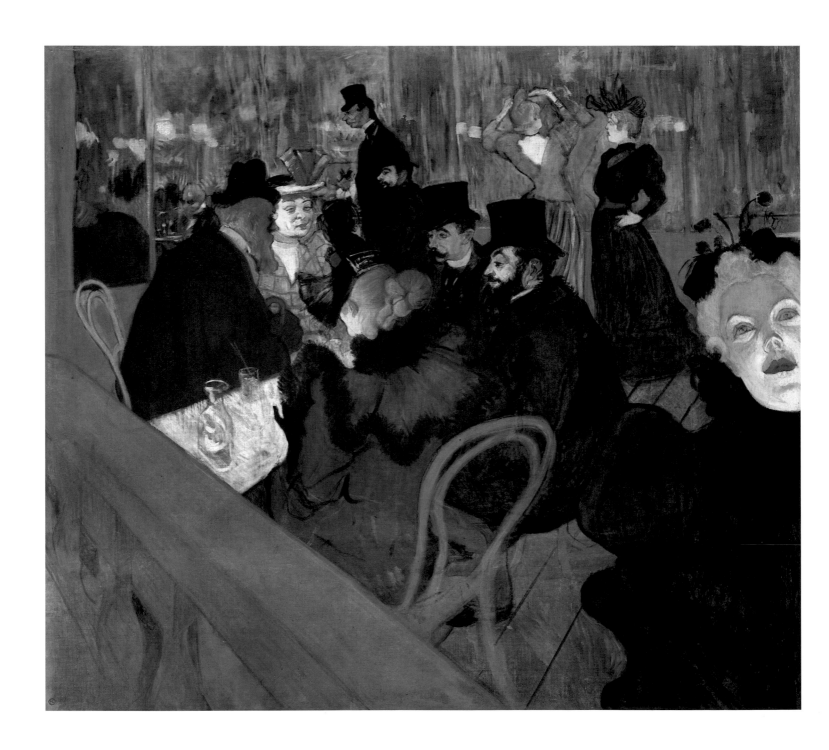

Henri de Toulouse-Lautrec, like his mentor Edgar Degas, often focused his attention on the dramas happening in the audience of the theater or café-concert rather than on the stage. In *At the Moulin Rouge*, the single most important action – the departure of May Milton, her great, blue head floating off the canvas – occurs in the margin of the composition. The frozen expression of her face, illuminated by an invisible stage light so that it becomes a mask, contrasts with the various casual interactions that take place in the canvas's center stage. The painting's incisive and daring composition, with its unusual perspective and cut-off, flattened figures, its dramatic palette, and the sensational world it depicts have made it Toulouse-Lautrec's most memorable and perhaps his greatest painting.

The Moulin Rouge was the most important café-concert in Paris during the 1890s. Toulouse-Lautrec was a regular patron of the establishment; his painting *In the Circus Fernando* (p. 26) hung in its lobby. He knew many of the most famous entertainers at the Moulin Rouge, as well as its habitual customers, and he documented both with extraordinary rigor and detail. His paintings of the denizens and establishments of the Montmartre district can be read as chapters in a great novel about Paris at night, capturing the intrigues, the gossip, the flirtations, the loneliness, and the despair of this life.

The room in the Art Institute's picture resembles a glass aquarium with mirrored sides, and its occupants seem to float in its ambiguous, ethereal waters. We see the dancer La Goulue preening in a greenish mirror, while her friend, called La Mome Fromage, stands nearby, looking into a distant room which is barely visible behind the glass partition at the upper left. The five people seated around the table, intent on their conversation, turn their collective backs on the departing May Milton, who was apparently ostracized from this group in 1895. The three men are a photographer, a vineyard proprietor, and a poet; the two women are the entertainers Jane Avril and La Macarona. Passing out of the room, just behind the central group, is the tiny figure of the artist himself, accompanied by his tall and devoted cousin, Tapié de Céléyran.

At the Moulin Rouge has always been dated 1892 and thought to have been enlarged by the artist at the bottom and right in 1895. Recent examination has shown that this was not the case. *At the Moulin Rouge* was painted in 1894/95 and cut down after the artist's death, probably to make its composition less radical and more saleable. It was reassembled sometime before 1924, when it was exhibited at the Art Institute in a special exhibition devoted to Toulouse-Lautrec's work.

THE INFLUENCE OF NEO-IMPRESSIONISM

The inclusion of Georges Seurat's *Sunday Afternoon on the Island of La Grande Jatte* (The Art Institute of Chicago) in the final Impressionist exhibition, in 1886, had a profound effect on the subsequent development of European art. Before the year was out, artists as diverse in age and aesthetic temperament as Camille Pissarro, Vincent van Gogh (see p. 8), and Paul Signac had begun to adopt Seurat's technique, which he called Scientific Impressionism but which became known as Neo-Impressionism. Neo-Impressionism consisted of applying spots of pure color side-by-side on the canvas so that, theoretically, the viewer's eye would automatically mix the juxtaposed colors, thereby creating truer and more intense shades. By the early 1890s, there were hundreds of artists throughout Europe influenced by Seurat's technique who were painting dots of color on thoroughly organized canvases.

Georges Lemmen's *Portrait of the Artist's Sister* and Henri Edmond Cross's *Beach at Cabasson* are two works created by artists early in the Neo-Impressionist phase of their careers. Lemmen had painted smooth, objective renderings of the people and interiors of his native Belgium before turning to Seurat's technique in 1890. Cross (who changed his name from Delacroix to its English equivalent to avoid connections with the great Romantic painter) had been a successful Salon painter whose beautifully constructed, sensuous paintings of the late 1880s show little evidence that he would become susceptible to the influence of Seurat.

Lemmen's portrait of his elder sister, Julie, who never married and acted as a nanny to his children, reveals the emphasis on silhouette, simplification and abstraction of shapes, and Neo-Impressionist technique of his mentor, Seurat. In this beautifully painted composition, the spots of color vary in size depending on the degree of detail and subtlety of modeling that the artist wished to convey. Where Lemmen differed from Seurat was in his interest in personality. Julie Lemmen's delicate yet indestructible character, her sadness and severity, all are communicated through the avant-garde screen of dots that fixes her on the canvas.

Cross owed more to Seurat's technique than Lemmen did, for he adopted the decorative surface construction and abstract analysis of landscape as well as the dotted facture of Seurat's paintings. Seurat had died the year before Cross painted and exhibited *The Beach at Cabasson*, an investigation of the interplay between the human figure and the landscape – in this case, a beautiful stretch of beach along the French Riviera, near Cabasson, where the artist lived from 1891 until his death in 1910. One senses in Cross's arresting composition a form of conscious quotation from Seurat's work. The subject recalls the recently deceased artist's high-keyed beach scenes, and the three figures were derived from the three females in his *Models* (Barnes Foundation, Marion, Pennsylvania). Yet, these are not three boys on the beach together but one boy posed in three different positions and placed with hieratic precision along the plane in the foreground. The figures, who seem to move in slow motion before us, immobilize the landscape; they take it beyond time. Thus, the painting hovers mysteriously between Neo-Impressionism and Symbolism. The light depicted in the painting is the bright, eternal light of the Mediterranean, carefully observed by an inhabitant of the region, and, yet, the landscape is arranged in patterns so decorative that it becomes unreal.

Detail of
Beach at Cabasson

Henri Edmond Cross
The Beach at Cabasson
1891-92

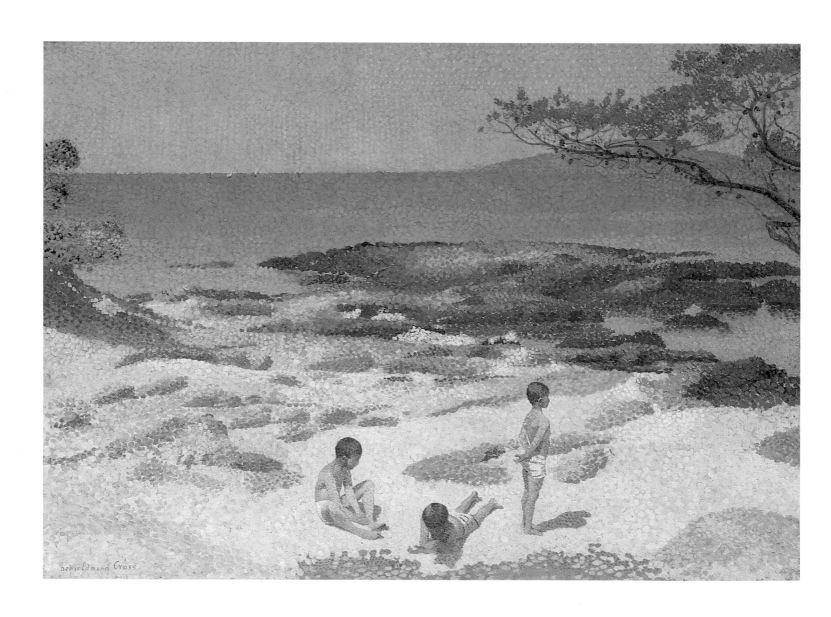

Georges Lemmen
Portrait of the Artist's Sister
1891

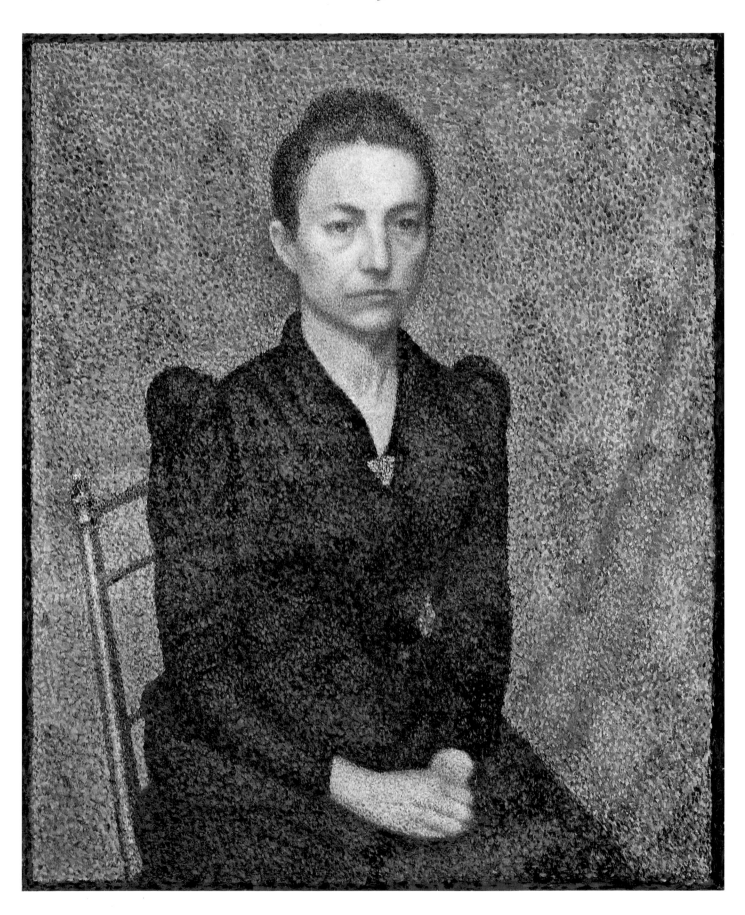

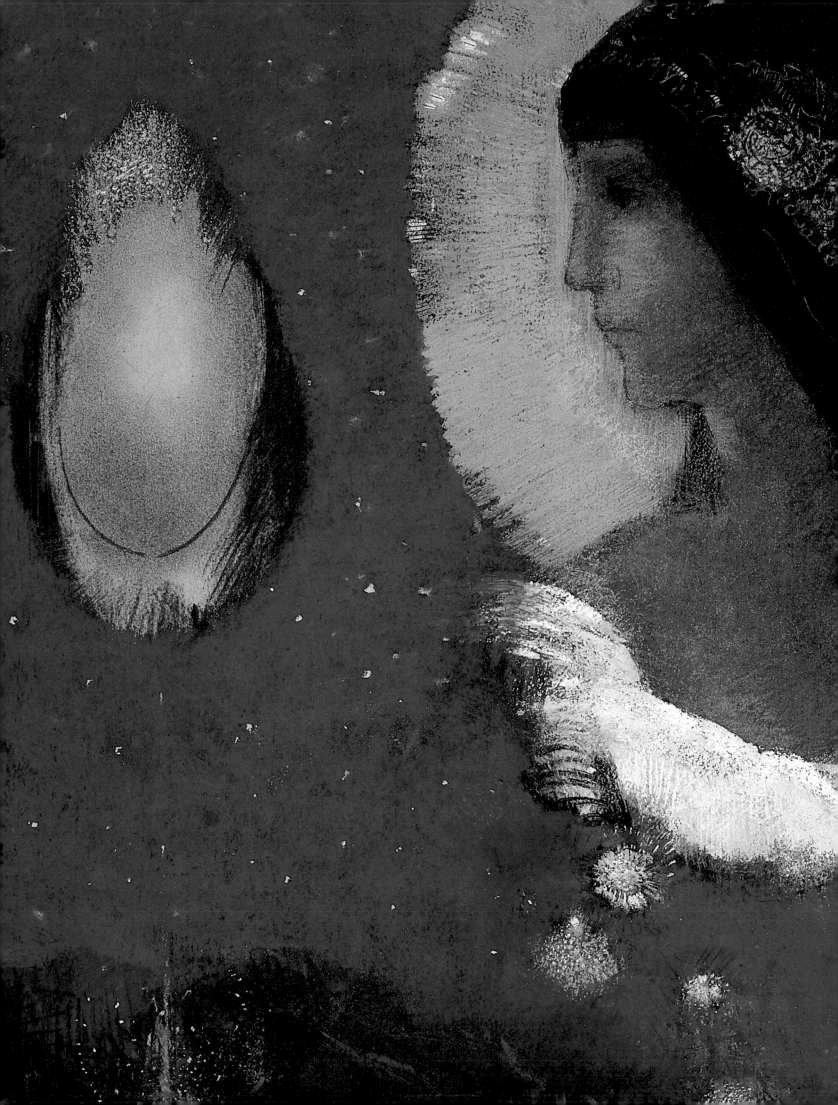

REDON'S SYMBOLIST PASTELS

While Odilon Redon was a contemporary of the Impressionists, his relatively slow development as an artist and his visionary, totally personal, imagery allied him with a younger generation of writers, artists, and musicians known as the Symbolists. Believing that artists can suggest the intangible – emotions, dreams, the spirit – they attempted to liberate art from its function of describing objective reality. When most avant-garde artists were painting the world around them bathed in natural light, Redon was conjuring an imaginary world emanating from a primal darkness, hallucinations and fantasies that required the creation of a new visual language. Redon first became known for his *noirs*, works of art in black. Virtually all of his art from the 1860s through the mid-1890s was executed in black, with various white and cream papers masterfully employed to suggest light. Whether in charcoal, black chalk, or lithographic crayon, his *noirs* have a richness and evocative depth almost unknown in the late nineteenth century.

As early as the 1880s, Redon began to animate his *noirs* with color. His first efforts were tentative, but in several sheets he used color to convey mood and to heighten the symbolism of his subject. Such is the case with *Dawn of the Last Day*. Using pale blue, yellow, and white pastel and touches of gouache, he created an aura of chilly light around the great, blank orb that infiltrates the dark, rocky landscape and illuminates, with deft, subtle touches, a seated female figure who seems to have been carved from the same stone as the formations around her. The night that the glowing sphere invades is apparent only in the landscape's profound shadows, created with charcoal. The orb's cold, apocalyptic light does not release the muselike figure from her somnambulant,

frozen state. In this work, Redon only began to understand the power of color.

By the mid-1890s, the artist began to make pastels and oil paintings that are the very opposite of his *noirs*. Rather than expanding his palette gradually from black to blazing color, Redon skipped the intermediary steps and quickly became one of the supreme colorists of French art in the late nineteenth and early twentieth centuries. The disembodied heads, floating forms, winged beasts, and flowers remain from his earlier works; yet, the subtle harmonies and brilliant flashes of luminescent color so transform this repertory of subjects that his art seems to have changed in every way.

Woman Among Flowers represents the head and upper torso of a nude woman against a lush background of leaves, blooming plants, and flowers. The background is so exotic that it is difficult to accept it as real. So, too, the female form, only rudimentarily defined, is absolutely substanceless. There are no arms, no breasts, no shoulders, only intimations of them. Even her face barely exists, so finely drawn are her features. Like many heads in Redon's work, the eyes are closed, perhaps suggesting that the fantastic vegetative realm around her might be the embodiment of her private thoughts and dreams.

Evocation seems to have begun as a *noir*, for the black passages over yellow-brown paper in the area at the left of the composition seem to be revelations of a work of art beneath the layers of pastel. The sheet represents the head of a young man in profile. Wearing a jeweled headdress, he is surrounded by a brilliant green halo that seems to glow like a phosphorescent substance. Other forms burst with light from somewhere within the space like fireflies or fireworks seen from a distance, and the color is so

rich that it suggests precious stones ground and mixed to become pastel. There is nothing soft about Redon's hues: they throb, pulsate, and glitter. The title of this pastel is revelatory of Redon's aims. As the artist wrote in 1909:

Titles can be justified only if they are vague, indeterminate, or suggestive, even at the risk of confusion, of ambiguity. My drawings are not intended to define anything: they *inspire*. They make no statements and set no limits. They lead, like music, into an ambiguous world where there is no cause and no effect.

A Symbolist before the movement was named, Redon was among the most unique artists of his time.

Nonetheless, there are many ways in which his art relates to that of his contemporaries. In developing his work in color, Redon looked particularly to the art of his friend Paul Gauguin, whose search for basic, spiritual truths led him to exotic cultures and to an original style of abstract color and form in his paintings (see pp. 60, 71). Redon's choice of pastel owes a debt to the highly experimental work in this medium by Edgar Degas (see p. 96). While Degas worked with his materials and techniques like an alchemist, Redon was more cautious and conservative. For that reason, each pastel by Redon is supremely well-crafted and perfectly calculated to mystify and to inspire.

Odilon Redon
Evocation
c. 1905/10

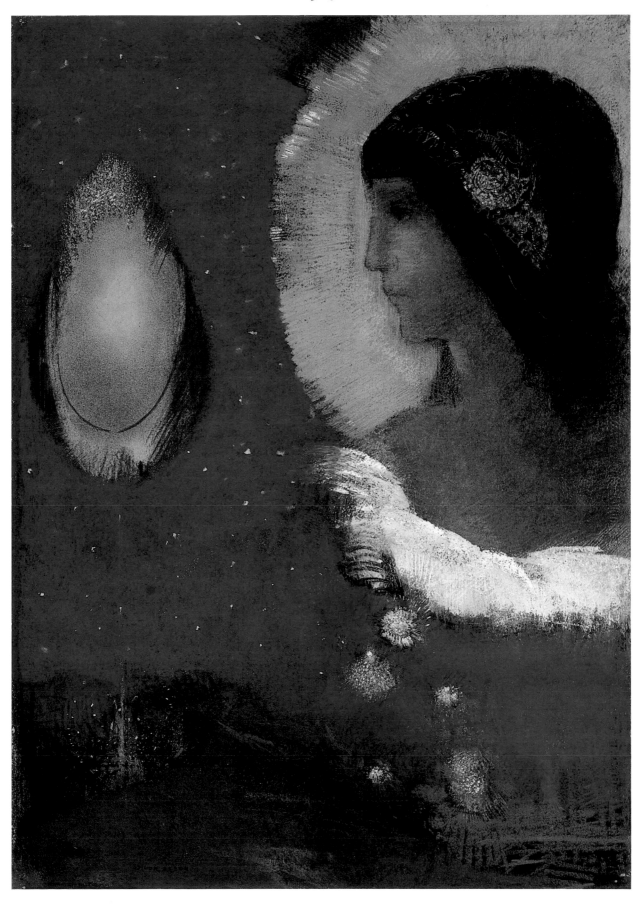

Odilon Redon
Dawn of the Last Day
c. 1880/85

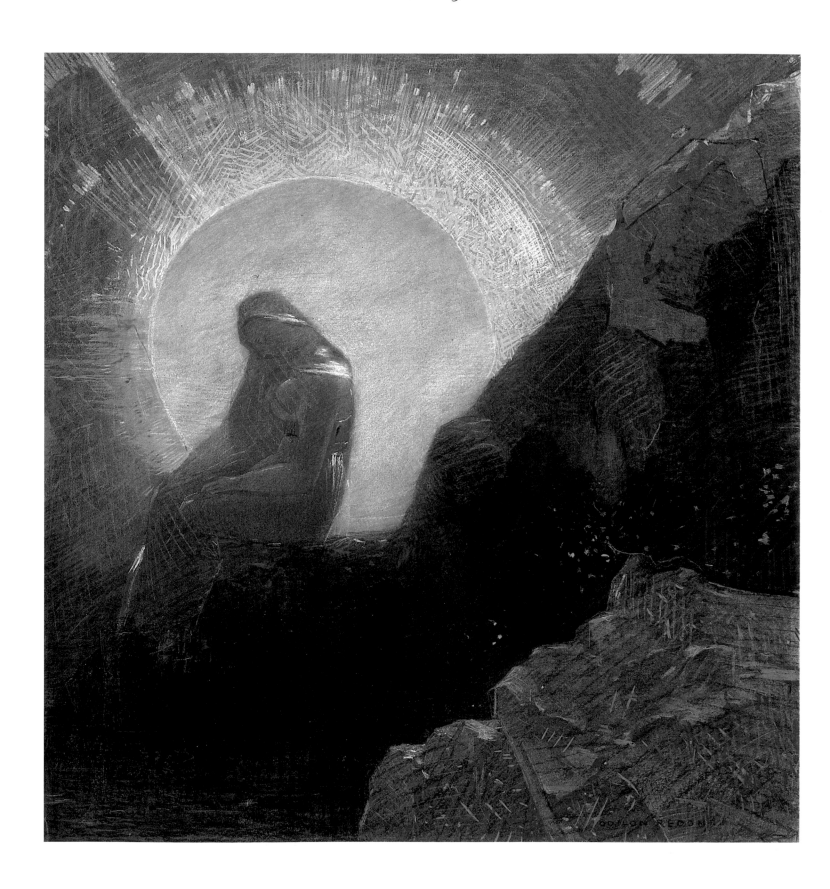

Odilon Redon
Woman Among Flowers
c. 1900

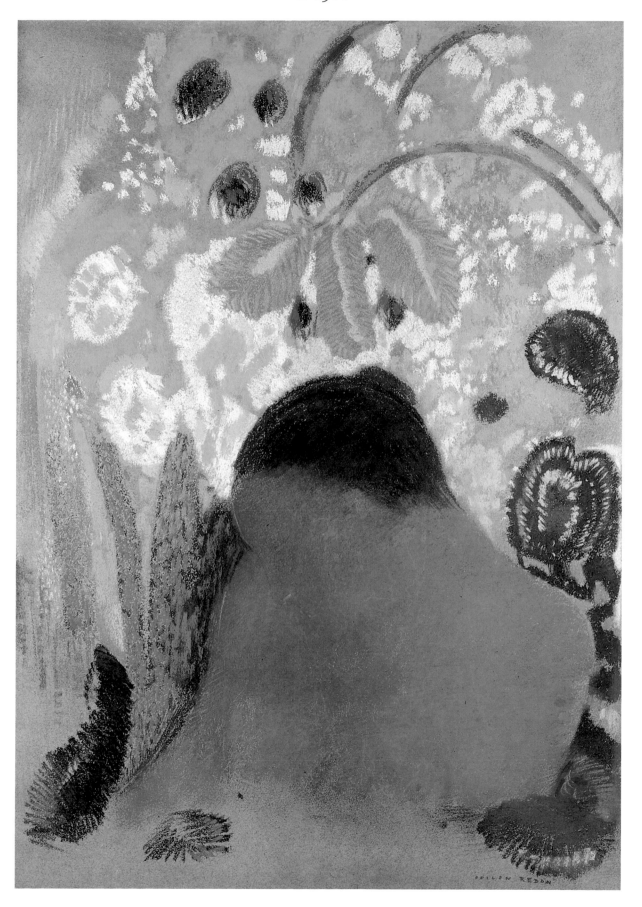

Paul Gauguin
Ancestors of Tehamana
1893

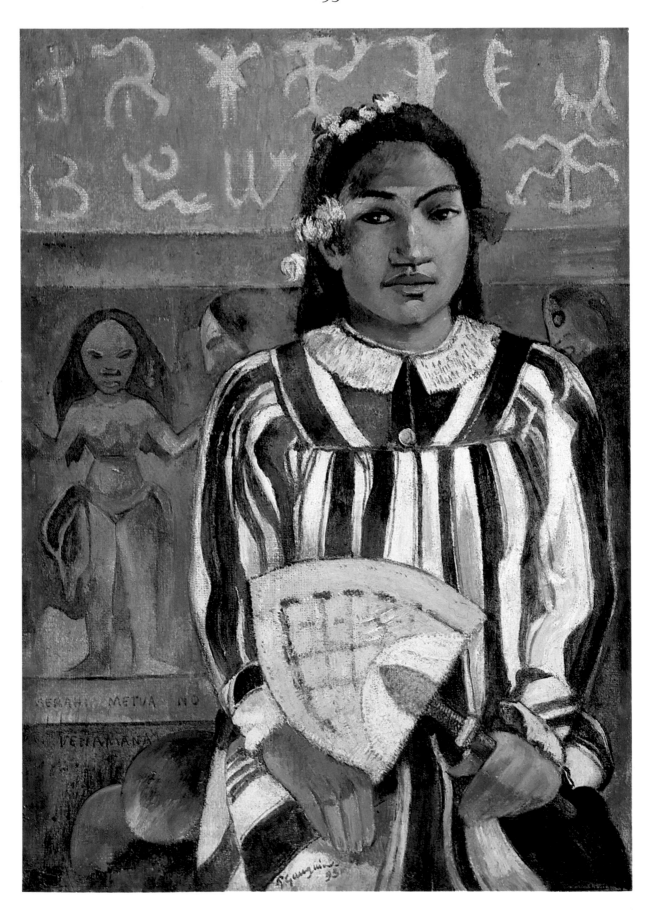

Paul Gauguin arrived in Tahiti in June 1891. Tahiti had been discovered by Europeans more than a century before and was, by 1891, resolutely colonial. Gauguin's aims in traveling to Tahiti were financial and spiritual (he imagined that he could live for almost nothing in a pre-capitalistic society, and he thought that this truly primitive place would be a paradise). He was disappointed on both counts and fled Tahiti for France after a period of about two years.

If his life was more problematic than he had expected, the art he created in the South Pacific fails to reflect that difficulty. The paintings, drawings, watercolors, prints, and texts he produced in Tahiti present an image of an intoxicating earthly paradise where the painter lived as a native among the natives. *Ancestors of Tehamana* is a portrait of Gauguin's young Tahitian wife, Tehura. Although the most famous paintings and writings about the beautiful Tehura describe her in the nude and involve either images of sleep or of lovemaking, this is definitely a portrait and recalls in many ways his *Portrait of a Seated Woman* (p. 31). In each work, Gauguin placed his model in a seated position in front of a painting. In each, the woman is carefully dressed without a hint of sexual provocation, and fruit is included.

Gauguin depicted Tehura against a painted wall decoration divided into two major sections. The striped dress, flower-decorated hair, and contained pose of Tehura contrast with the stylized gesture of the female figurine behind her. Yet, surely Gauguin was implying a strong, if silent, bond between these two figures. Their strictly frontal posture, the profiled heads behind either shoulder of Tehura, the direction in which her Tahitian fan is pointed, and even the way in which she glances to the left all reinforce the connection suggested here between the present and the past, the living and the dead, the corporeal and the spiritual.

What is ultimately so mysterious and fascinating about this work is its painted background. It resembles a frieze on the wall of a palace or temple interior. The writing in the upper portion of the frieze is unintelligible: Is it some form of Polynesian epigraphy? Is it a sacred text? Was it written by the ancestors of Tehamana? Are the painted figures in the next rung of the frieze representations of these ancestors? The wall decoration ends at the lower boundary of the painting with two mysterious fruits. Too large to be oranges, too orange to be apples, too flat to be real, these fruits allude to the art of Paul Cézanne. While Cézanne worked in isolation in the south of France, rarely, if ever thinking of Gauguin, Gauguin worked in isolation in Tahiti with the work of *Cézanne* constantly on his mind.

Paul Gauguin
Mysterious Water (Papa Moe)
c. 1893/94

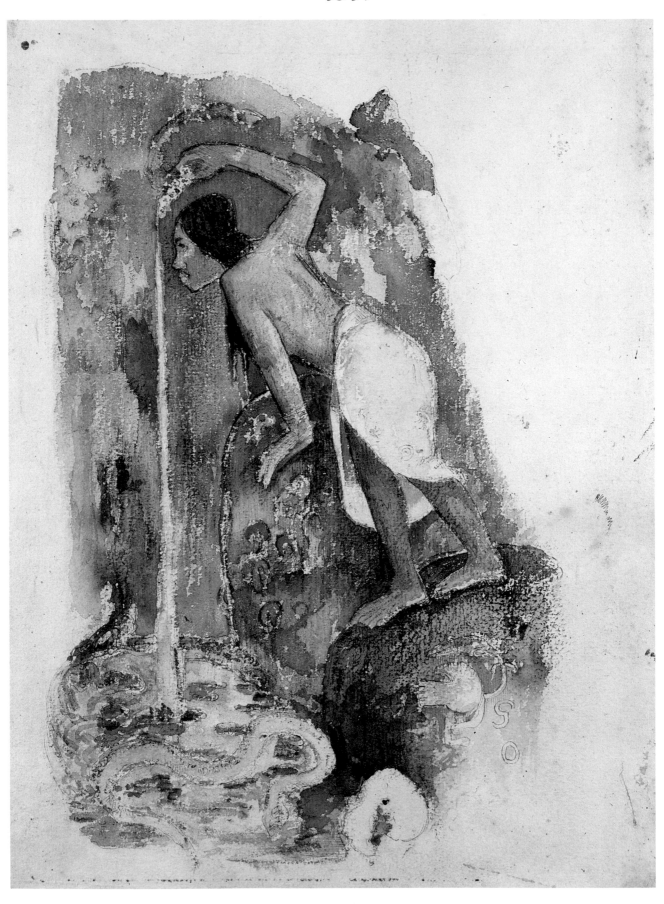

Paul Gauguin translated the Polynesian title *Papa Moe* as "mysterious water" and attached great significance to this purest and most elemental of liquids. In his Tahitian paintings, pools, rivers, waterfalls, and beaches abound. In *Mysterious Water (Papa Moe)*, a muscular young woman leans against a rock to drink the mysterious water that flows gently from a spout into a pool of water, where little waves and rivulets dance.

Gauguin made an important painting of this subject (private collection, Zurich) in 1893 and included it in the first exhibition of his Tahitian paintings at the Durand-Ruel gallery in Paris in that year. Scholars have known that he derived the composition for *Mysterious Water (Papa Moe)* from a photograph made in Tahiti in the 1880s, long before his arrival there in 1891. Perhaps, for that reason, the composition has a contrived, posed quality seldom seen in Gauguin's other works of the period. Gauguin made several interesting changes in translating the photograph into a work of art. Probably, the most important is his deemphasis of the sex of the figure. In the photo, she is a full-breasted young woman, but in the painting the figure's gender remains somewhat unclear, almost androgynous.

This watercolor of the composition has been variously dated by scholars, some maintaining that it was made sometime between 1891 and 1893 in preparation for the painting. It is more likely, however, that the watercolor was done in France in 1893-94, when Gauguin began a series of prints and watercolors of his Tahitian subjects to use as illustrations of his first important book, a memoir-cum-novel he titled *Noa Noa*. Much of the text and its related prints and drawings were made in Pont Aven in 1894, but the final manuscript, now in the Musée du Louvre, Paris, was not completed by Gauguin until 1897. Both the scale and character of his watercolor relate it to the *Noa Noa* manuscript, in spite of the fact that it was not included in the final version. There is, however, a section of this book in which Gauguin created a text for an image he had already conceived and painted:

Suddenly, at an abrupt turn, I saw a naked young girl leaning against a projecting rock. She was caressing it with both hands, rather than using it as a support. She was drinking from a spring which in silence trickled from a great height among the rocks. After she had finished drinking, she let go of the rock, caught the water in both hands, and let it run down between her breasts. Then, though I had not made the slightest sound, she lowered her head like a timid antelope which instinctively scents danger and peered toward the thicket where I remained motionless. My look did not meet hers. Scarcely had she seen me, then she plunged below the surface, uttering the word: "*Taëhaë* (furious)." Quickly, I looked in the river – no one, nothing – only an enormous eel which wound in and out among the small stones at the bottom.

Paul Gauguin
Day of the Gods (Mahana No Atua)
1894

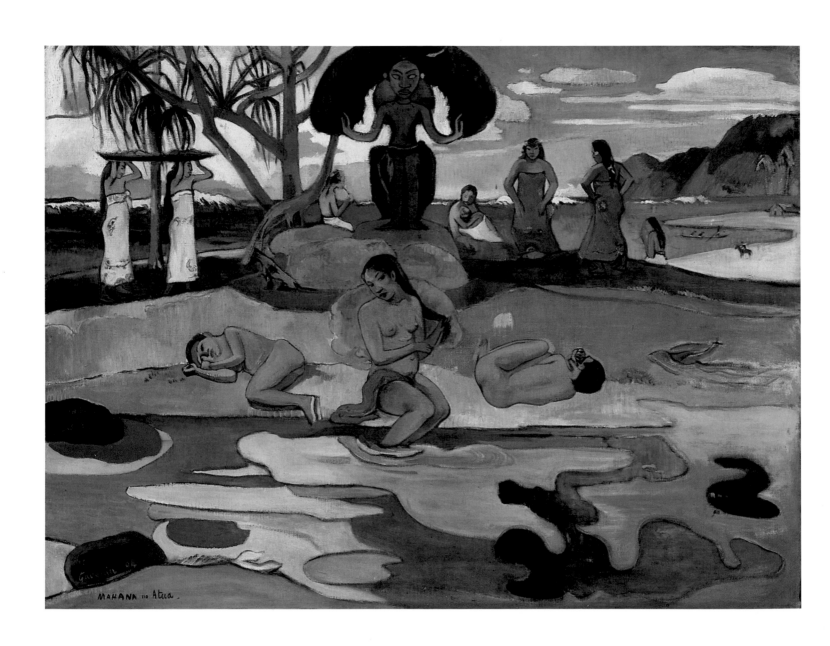

Late in 1893, Paul Gauguin returned to France from Tahiti and spent much of 1894 either in Paris or in the small Breton village of Pont Aven. His health was poor and his financial situation even worse; this state of affairs was not made any easier by the fact that he was all but ignored by dealers and critics. Perhaps, as a result of this situation, his output of painting declined dramatically in 1894, especially when compared to his intensely productive years in Tahiti.

Of the sixteen paintings Gauguin executed during that year, only two can be called unqualified masterpieces, and both represent not Pont Aven or Paris, but Tahiti. One of these is *Day of the Gods (Mahana No Atua)*, a painting that is the pictorial summation of the painter's experience on the South Pacific island. At once a travel picture and a devotional image, the composition deals more forthrightly than any other by Gauguin with Polynesian religion. At its center is the image of the idol Hina, which Gauguin derived less from Tahitian or Polynesian traditions than from Indian and Southeast Asian prototypes. For this reason, the painting can be interpreted as representing a universal, non-Christian religion.

Surrounding the idol is a beach scene with the mountains, huts, and trees Gauguin depicted so often in other Tahitian compositions. This scene includes dancers, a flute player, a pair of women carrying food or some offering to the god, and two figures in an embrace. Yet, this is merely a background for the real subject of the picture: the reflective pool and the three figures in the foreground. Basically abstract and nonrepresentational, the pool seems to have depth on the left side of the picture, but is utterly flat and two-dimensional on the right, and its colors do not correspond logically to others in the picture. Gauguin seems to have decided to represent some higher, more mysterious, reality in precisely the place where the actual world would be reflected. In this composition, the pool seems to express Gauguin's belief that the central purpose of art is to evoke symbolic realms rather than to represent the visual world.

At the edge of the pool are three young women posing as the three "Ages of Man" – birth, life, and death. Significantly, the central figure, representing life, has placed both feet in the pool of colorful reflections; the figure at the left, representing birth, touches the water only with her toes; and the figure at the right, symbolizing death, turns away from the pool completely.

Ultimately, Gauguin's intent in this painting is unclear; he deliberately veiled his purpose, preferring to be mysterious rather than clear and avoiding simple pictorial representations in favor of complex, multivalent symbols.

Henri de Toulouse-Lautrec
May Milton
1895

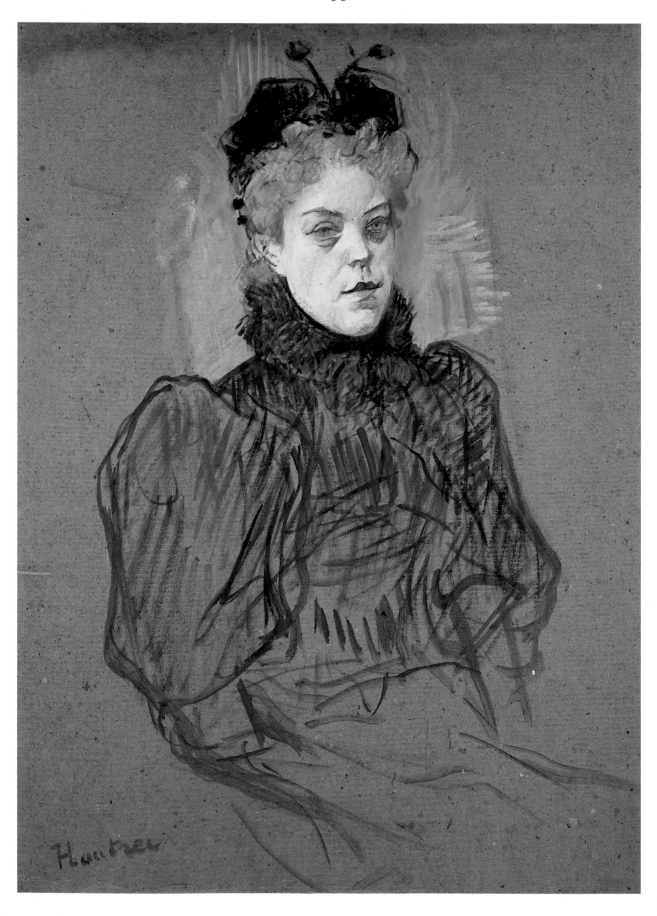

May Milton was an English dancer who performed both in England and France during the 1890s. Henri de Toulouse-Lautrec met Milton in 1895, the year in which this portrait was painted, through a mutual friend, the dancer Jane Avril. It is clear from the sketchy character of the painting (only the head is well developed), that is was done from life in one or two sittings. Lautrec produced several portraits on cardboard like this, in which the careful definition of the head contrasts with the minimal depiction of costume and background.

The portrait is certainly not flattering. The image of Milton's pale, somewhat bloated, face offended one early viewer, Gustave Coquiot, who saw it in the collection of the critic Théodore Duret. Coquiot wrote: "May Milton with a swollen face, with a heavy jaw, whitish yellow in color, as if retaining a magma of pus turned to yellow and pale green beneath a bladderous envelope." Perhaps, this portrait reminded Coquiot of the disturbing apparition of May Milton, wearing the same dress and hat, at the far right of Toulouse-Lautrec's greatest painting, *At the Moulin Rouge* (p. 44). In any case, Coquiot's vituperous comments seem unwarranted and are probably based on a subjective response to Milton's character rather than to her appearance in this particular depiction of her. In the portrait, she seems perfectly self-possessed, if a little bored, and her face is no less attractive than those of dozens of sitters portrayed by Toulouse-Lautrec, Edouard Manet, or Edgar Degas. Toulouse-Lautrec's skill as a caricaturist and in capturing likenesses was greater than that of his contemporaries, and he certainly succeeded in communicating the physicality and peculiarity of May Milton in this image of her.

While it is obvious that the painting was made with the sitter's permission, she never owned it. May Milton, in fact, disappeared from the retinue of Toulouse-Lautrec and his Montmartre friends in 1895 and went on to perform in the United States. The fact that this portrait seems unfinished did not deter the artist from exhibiting it in 1898 in London, where she was certainly well-known as a popular entertainer.

Paul Cézanne
Madame Cézanne in a Yellow Armchair
c. 1893/95

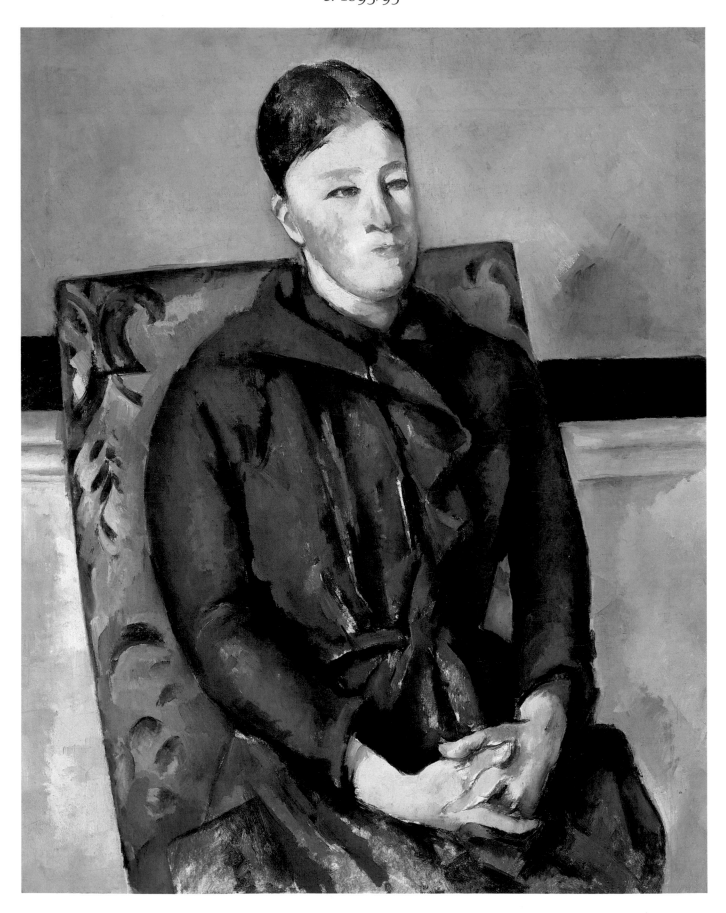

By all accounts, Paul Cézanne's marriage was not an easy or close one. If one can read between the lines, so to speak, of Cézanne's portraits of his wife, one can sense something of the tensions between them. In this painting, Madame Cézanne appears to bear her trials as wife and model with a supreme patience that borders on indifference. Her face resembles a mask, with its almond eye-slits and simplified nose. Her hair is pulled tightly back, her lips are sealed. Yet, she seems to fidget with her hands. The implied movement of the hands belies the apparent calm of Madame Cézanne's pose and self-absorbed expression.

Cézanne painted three portraits of his wife in the same damask-covered yellow chair, and they appear to have been done within a very short period. The largest and most complex of the three, at The Metropolitan Museum of Art, New York, includes elaborate drapery, the edge of a mantelpiece, and a fire tong. The Art Institute's portrait and a third version, in a private New York collection, are smaller and simpler. In each, Madame Cézanne is identically posed and the props are reduced to the chair and the wainscoting of the wall behind. The classical calm and regularity of these portraits combine with a certain bourgeois simplicity. Cézanne refused to allow even a hint of fashionability to enter here: his wife wears no hat or jewelry, and the chair is a type commonly found in French middle-class houses from the seventeenth through the nineteenth centuries.

For Cézanne, the execution of a portrait involved the same demands as a still life: the structure of the figure, the definition of forms and relation between them, the orchestration of color in building the composition – all required careful consideration. The two smaller versions of *Madame Cézanne in a Yellow Armchair* seem to have been exercises in the use of the three primary colors – the red of the dress, the yellow of the chair, and the blue of the wall. In each, Madame Cézanne's face has been painted with myriad hues, but the purple-red, yellow, and blue come together in small patches around the mouth. The composition has been organized into a series of horizontal and vertical lines and ovals. The lines, set on a diagonal bias, are echoed in the careful arrangement in the features and shadow on the face. The oval head is repeated in the shape of the body within the slightly bowed arms, the pattern of the upholstery, and the hands. The stillness of the pose and reserved expression of the sitter are set against subtle manipulations of the background and chair. For all of the apparent resistance by Madame Cézanne to revealing here anything about her thoughts and feelings, in the Art Institute painting Cézanne succeeded in creating a depiction of her that is at once dignified, complex, and monumental.

Paul Cézanne
Basket of Apples
c. 1895

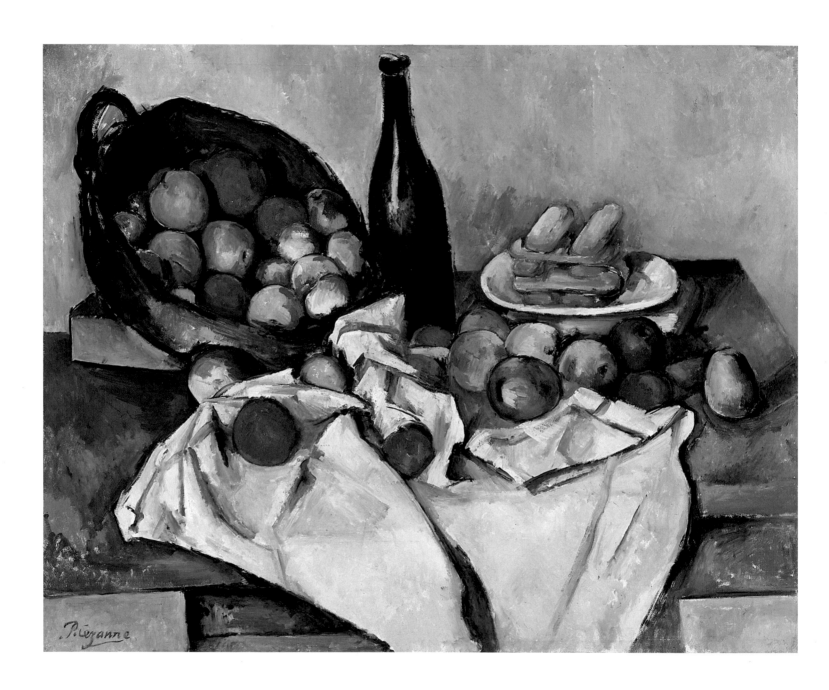

Paul Cézanne spent most of his working life in and around the southern French city of Aix-en-Provence and, partially as a result of his self-imposed isolation, was for many years all but unknown in Paris. In 1895, he was persuaded by the dealer Ambroise Vollard to have a one-man show in Paris. The exhibition, held at Vollard's popular gallery, was not an important financial success, but it had a profound effect on the history of French art. It was the first time in nearly twenty years that French artists who had heard about this painter from Provence could actually see his work.

Basket of Apples was among the paintings selected by Cézanne and Vollard for inclusion in this exhibition. Like several of the other paintings in the exhibition, it was signed, most probably at the insistence of Vollard, who felt that an unsigned painting might be considered unfinished and, hence, would fail to sell. Cézanne grudgingly complied, and, for that reason, the paintings in the Vollard exhibition are among the few the artist actually signed.

Basket of Apples is among Cézanne's "baroque" still lifes painted in the late 1880s and 1890s. Its pictorial structure derives from seventeenth-century Dutch still lifes. Like the Dutch artists, Cézanne sought to establish a dynamic, asymmetrical arrangement of objects that are held in place only by the painter's compositional skills. Yet, where such an effect of imbalance was merely a compositional device of the Dutch painters, it was an essential element of Cézanne's conception of the still life.

Cézanne recognized the fact that the artist is not bound to represent real objects in real space. He was able, therefore, to impart to everything a strength and relative position that could not possibly be duplicated in an actual studio arrangement. Here, the basket filled with apples tilts improbably on a small base or stand, its contents held in check only by a bottle and a cloth, in whose complex, craggy folds lie many other pieces of fruit. The table, like virtually every one in a Cézanne still life, has four edges that cannot be aligned to form an exact rectangle. At the raised upper right corner of the table, the artist created a latticed "log-cabin" of the French pastry called "dents de loup," contrasting the informal and unstable arrangement of the circular apples on the table with the architectonic stack of cookies. Both arrangements vie for dominance around the central form of the bottle, which, with its own silhouette shifting from left to right, acts as an anchor for a composition in endless flux. Thus, the balance that Cézanne achieved is a purely pictorial one: the actual arrangement of objects he painted in his studio could never have possessed the dynamism and tension with which it is endowed in *Basket of Apples*.

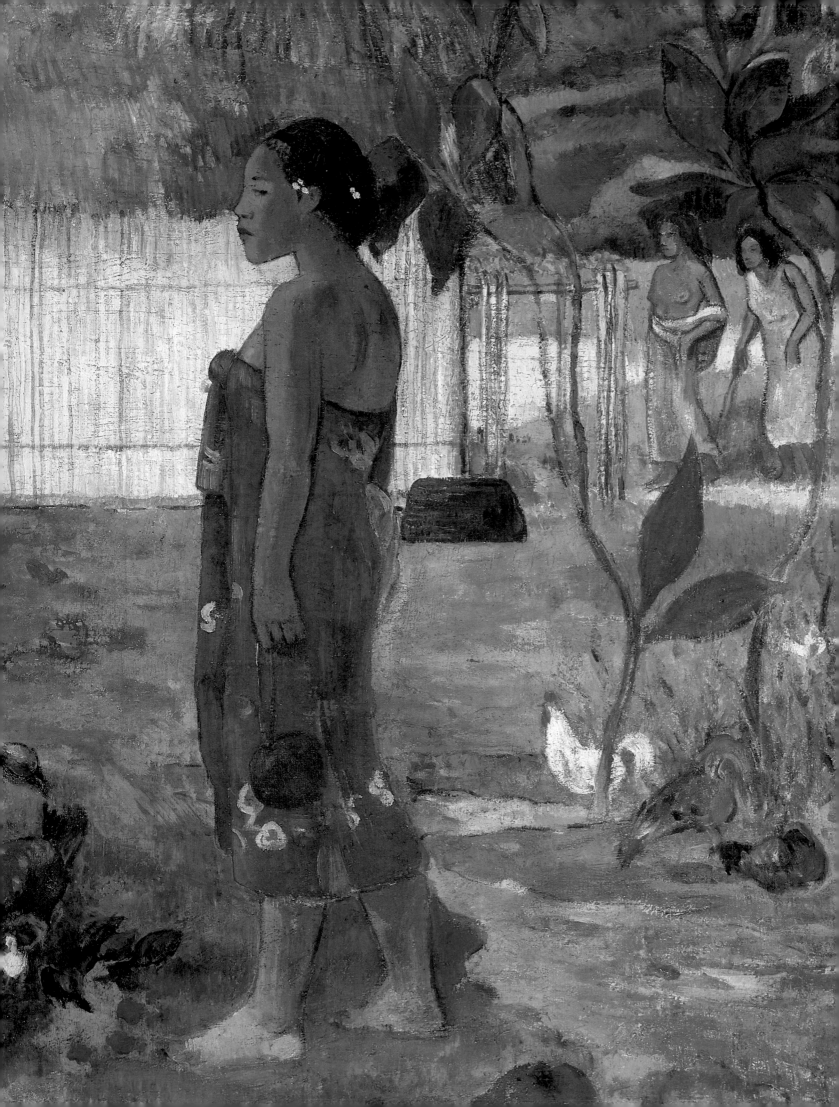

GAUGUIN'S SECOND TAHITIAN SOJOURN

In September, 1895, Paul Gauguin arrived in Tahiti for his second and final stay on that island. His return to France had been a dismal personal and financial failure, and he fled to Tahiti intending to finish his life there. During his voyage, he planned what he expected to be his final works, and, as soon as he arrived, he began six large canvases of identical dimension, five of which he completed in 1896, the sixth in 1897. *Why Are You Angry?* is among the first five of these compositions. The title he inscribed on the painting forces the viewer to interpret the poses and gestures of the figures in terms of human emotions. Yet, in the final analysis, the title succeeds in perplexing more than it enlightens, and the meaning of the painting remains elusive.

The standing figure in the right foreground seems at first to be the one asking "Why are you angry?" of the seated women in the left foreground. But, what is there in this pastoral scene to be angry about? The clue, if indeed there is a single, satisfactory one, might be provided by the hen with her brood of chicks and attendant rooster at the center of the composition. All of the figures in this painting are women; there are no men or children. Thus, one of the seated women could be angry that another (the standing female?) is involved with a man or is pregnant.

Whatever narrative Gauguin intended, he lavished a great deal of attention on this lush, exotic canvas. Each section is worked with layer upon layer of paint so that there are no simple areas of color. Every hue is shot through with others to create a gently pulsating color field. The palette of this painting is brilliant, even in the shaded area in the foreground where the women escape the tropical heat. The only dark, mysterious portion is the entrance to the hut. It is perhaps significant that this opening is presided over by a seated old woman who watches the interaction of the younger women with the humor and wisdom of her advanced age. Unlike them, she knows the answers to the secrets they struggle to understand and is past the anger that youthful competition engenders. So, too, Gauguin's art in this, his late period, exhibits a resolution and reserved calm that reveal the mastery of a mature artist at the peak of his powers and not the decimated and hopeless personality that his biography might indicate.

While Gauguin is known principally as a painter and as one of the great colorists of modern art, less well-known, but equally revolutionary, are his graphic works, particularly his prints. The Art Institute is fortunate to possess the largest and most important collection of Gauguin's prints in the world, surpassing even those in the French national collections. These two evocative woodcuts have been selected from this large body of work because they are among the most expressive and moving in Gauguin's graphic oeuvre. He used the medium of woodblock printing in ways that were entirely new in the history of art. Rather than cutting the woodblock, inking it regularly, and then printing an edition of identical prints, Gauguin adapted the interpretive process of the Impressionist printmakers Edgar Degas and Camille Pissarro. Those artists had used the medium of etching with great inventive flair, returning again and again to the plate and rethinking the entire work of art each time they printed it. As a result, each impression of an Impressionist etching is usually unique and was intended to be so.

Although Gauguin made few etchings, his woodblock prints were achieved with the same consideration for the variable quality of each print. Gauguin used complex inkings and multiple printings to pro-

duce impressions from a single block that varied dramatically from one another. Such is the case for the impressions from the block entitled *Here They Love (Te Faruru)*. In certain versions of this print, the bodies of the embracing lovers are clearly defined and surrounded by a fine linear pattern of disembodied heads, leaves, and flowers; in others, the bodies of the larger, strong male and the smaller, yielding female merge one into another and into the background. Certain impressions were colored by hand, others not. Perhaps the most moving impression of this print is illustrated here. The block was probably inked three separate times: first in black, then brown, then red and ocher. The last colors, however, may have been applied by hand. The tactile nature of the subject – making love – is emphasized by the deep, velvet effect Gauguin achieved, but, at the same time, the work expresses an intense melancholy. Indeed, if the title were not included in the print, it could at first glance be interpreted as depicting the body of a sick woman being held in a last embrace by a man. The wave- or hairlike forms that cut a diagonal path across the upper right-hand corner of the print and the swirling drapery of the figures relate this work to the Art Nouveau style prevalent in France during these years.

Fisherman Kneeling Beside His Dugout Canoe is more brilliantly colored but technically simpler. Here, Gauguin covered the woodblock heavily with black ink or another substance and waited until it was partially dry before he printed it. By hand-coloring it afterward with watercolor or diluted gouache, he was able to produce the trembling, textured effect seen in this superb impression, thereby differentiating it from all other impressions. The subject here was first used in two important paintings (*The Fisherman's Family,* Hermitage State Museum, Leningrad; *The Fisherman,* Museu de Arte Moderna, São Paulo) by Gauguin in 1896, but he transformed all of the elements of this composition to fit the format of the print. In the print, a naked fisherman quenches his thirst beside a small stream before setting out to sea in his wooden canoe. His right arm is raised in a graceful gesture that evokes an ancient rite or dance. Gauguin's emphasis on the woodiness of the printing block, the indications of process left in the prints, and his strongly sensual as well as symbolic content provided a direct inspiration for many twentieth-century printmakers, especially Munch and German Expressionists such as Schmidt-Rotluff, Kirchner, and Heckel.

Paul Gauguin
Why Are You Angry? (No Te Aha Oe Riri)
1896

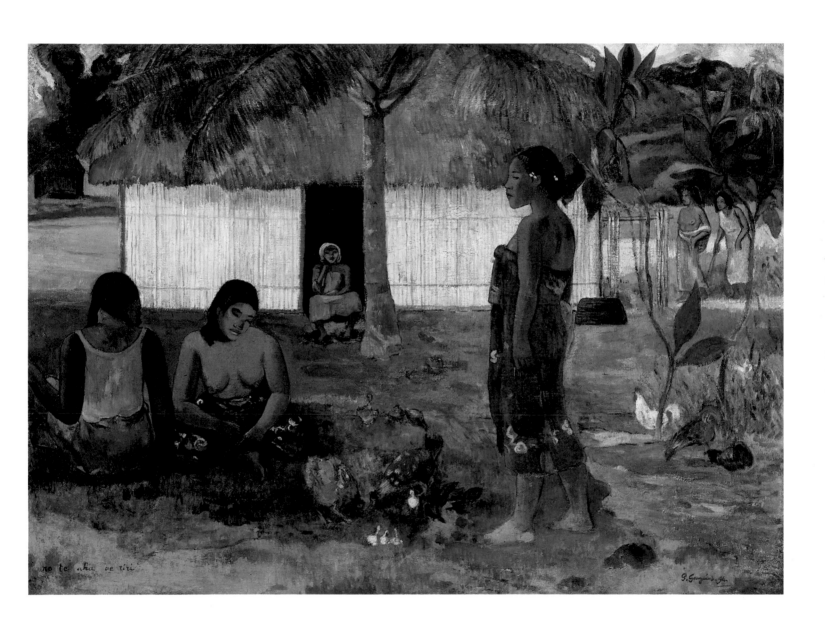

Paul Gauguin
Here They Love (Te Faruru)
c. 1893/95

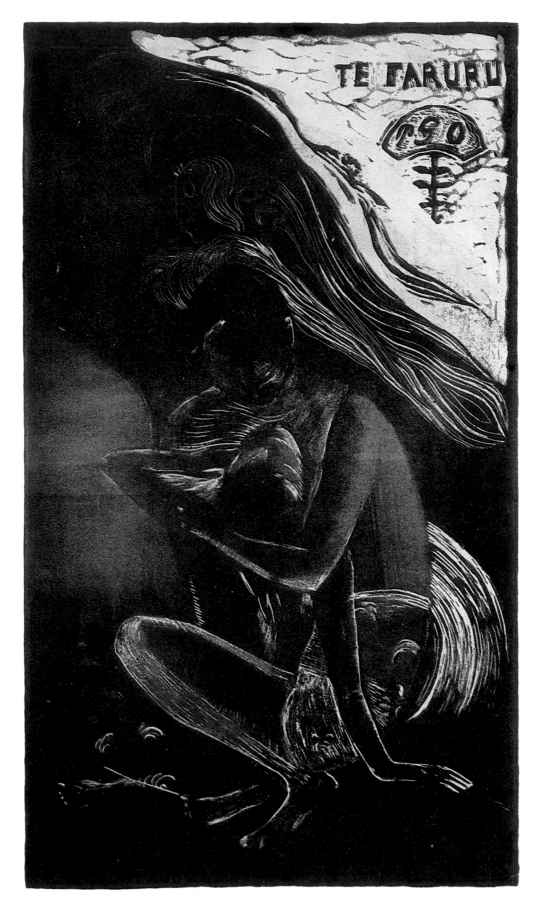

Paul Gauguin
Fisherman Kneeling Beside His Dugout Canoe
c. 1898

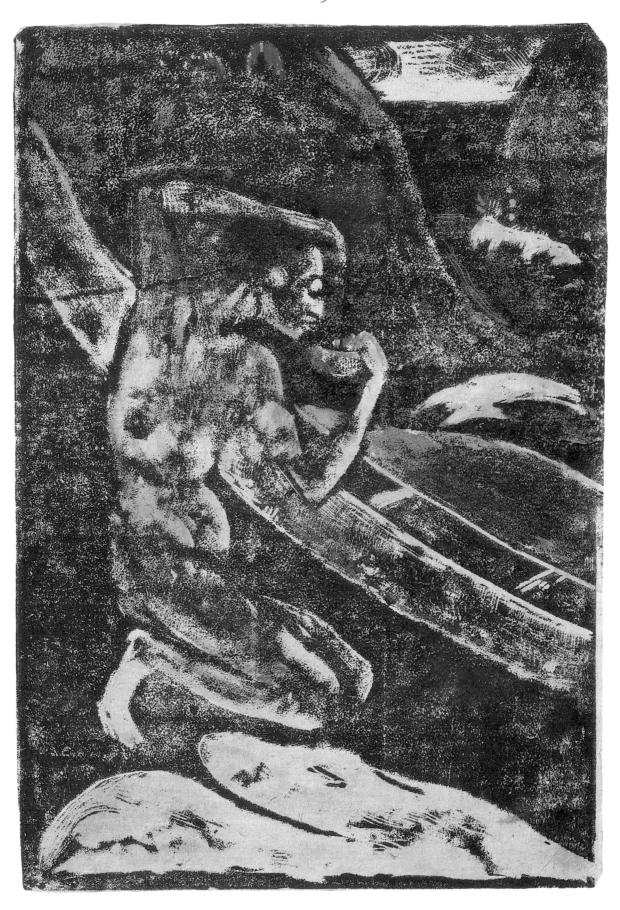

Paul Cézanne
Bathers

c. 1899/1904

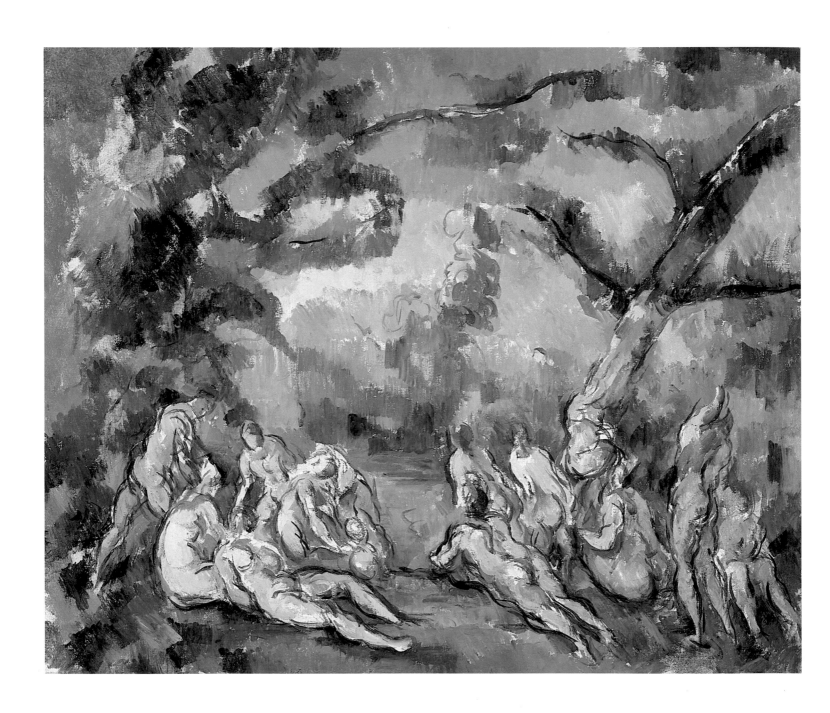

The subject of the nude figure in nature had interested Paul Cézanne in various ways since his early "Romantic" period. Clearly, he was attracted to the grand tradition of the theme established by Old Masters like Titian, Veronese, and Rubens, and continued in his own century by Courbet, Manet, and Renoir. Unlike these painters, Cézanne preferred not to work directly from the nude model, which perhaps contributed to the freedom with which he could pursue his explorations of abstract visual order.

In his later years, Cézanne was occupied with one painting in particular, the monumental *Great Bathers* (Philadelphia Museum of Art). Although it remained unfinished at his death, the painting can be considered not only as the culmination of his career but also as an important monument in the history of art. This canvas, and others in the series of nudes in landscapes associated with it, would serve as inspiration for many of the leading twentieth-century artists such as Pablo Picasso and Henri Matisse, who would push even further Cézanne's revolutionary experiments with abstracted form.

The Art Institute's *Bathers* is one of a group of canvases painted around the same time as *The Great Bathers*. Although it has been called a study for one of the larger paintings in Cézanne's late bather series, this is not the case. It does share certain details of setting and pose with the Philadelphia painting, but the basic character of the smaller composition is different. Where Cézanne sought to give the bathers massive volumes and geometric forms in the larger canvas, he managed to evoke a sense of lightness and movement in this smaller one. Indeed, *Bathers* seems to flicker with light and energy. The paint has been applied freely, with plenty of white, primed canvas showing through, almost as if to imitate the shimmering effect of watercolor, a medium at which Cézanne excelled (see p. 76). The trees, defined only minimally with vigorous brushstrokes, appear to sway broadly, as if pushed by strong breezes. The bodies of the women are suggested with multiple curved, sketchy lines. The result is that the viewer's eyes pass quickly over even the most solidly defined bathers, jumping from curve to curve, from body to body. Thus, Cézanne was able to infuse a powerful sense of life and energy even in this most intensely imaginary of scenes.

Paul Cézanne
The Three Skulls
c. 1902/06

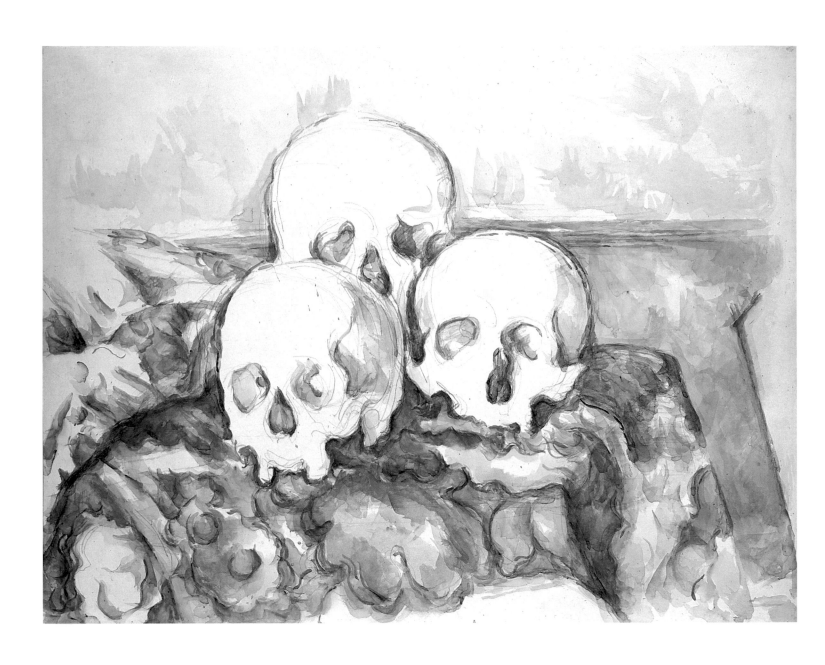

There is little doubt that Paul Cézanne was the greatest watercolorist of his time, imbuing his works in the medium with a mastery and exquisite delicacy unique in nineteenth-century French art. A major portion of his oeuvre was done in watercolor, with 645 listed in the definitive catalogue of Cézanne's work by John Rewald. The Art Institute has a superb collection of watercolors by Cézanne. Yet, none are as brilliant, or as haunting, as this large sheet made sometime during the last four years of the painter's life in his Lauves studio near Aix-en-Provence. The museum's director Daniel Catton Rich rhapsodized about it in the *Bulletin of The Art Institute of Chicago* shortly after it was acquired by the museum in 1954:

The skulls with all their powerful sense of volume are set in a curling rhythm of line and color which undulates with an almost baroque freedom. The broken S lines are repeated in the rich textile which is transformed from "real" material. . . into washes and strokes of red-orange, rose, clear green and radiant blue. Space no longer exists in well marked planes but is fused and pulled out at will.

Like many discussions of Cézanne's watercolors, especially from the 1950s, this eloquent appreciation emphasizes the formal inventions of the artist, ignoring or underplaying his subject matter. Three skulls on an oriental carpet – what could be more evocative? Why three skulls? Why are they on the carpet? The skulls are white (ironically, they are "nothing" but the white of the paper shining through the minimal marks that define their contours); the carpet is colored. The skulls are hard, almost architectonic structures; the carpet is soft, its folds curving and its designs swirling in informal patterns. It seems as if the carpet and skulls have been pitted against one another in a struggle of life and death.

And, yet, Cézanne succeeded here in knitting these two entities together, the sockets and jaws of the skulls forming patterns that are echoed in those of the carpet as if one realm is dissolving into the other. Thus, what might appear to be an allusion to death from the vantage point of the artist's old age is transformed by Cézanne's genius into a celebration of the relationship between things and the power of the artist's eye and hand to define and integrate them into a consistent and deliberate whole. *The Three Skulls* is anything but morbid; this superb *nature morte* (or "dead nature," as "still life" translates into French) is full of light and life.

Paul Gauguin
Tahitian Woman with Children
1901

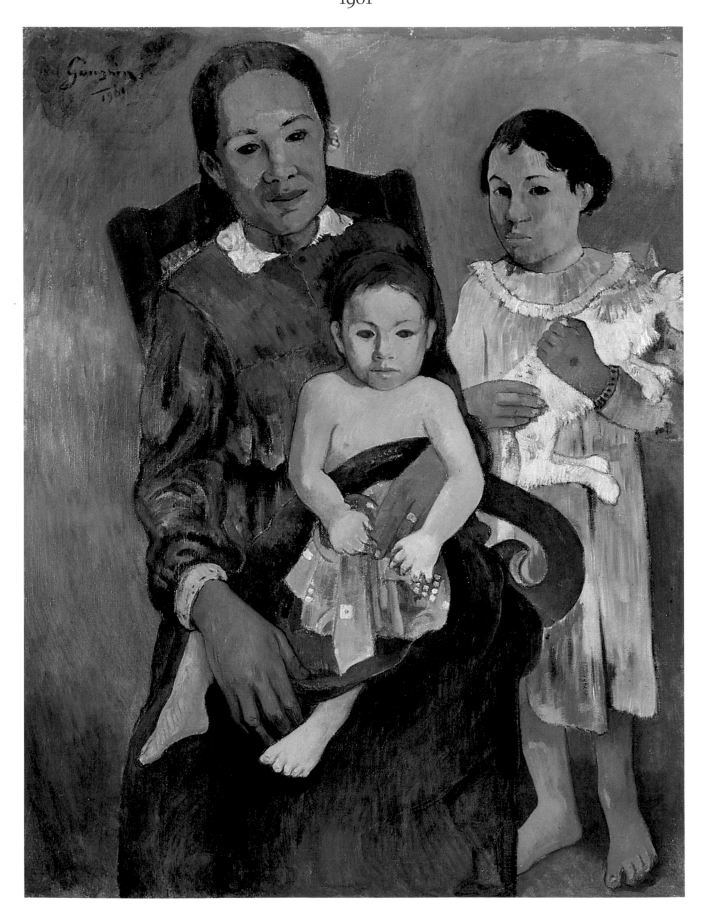

Paul Gauguin left Tahiti for the remote Pacific island of Atuana in the Marquesas in 1901. Already in ill health from advanced venereal disease, he was to die two years later on Atuana. The year 1900, his last full year in Tahiti, had been all but fruitless, with not a single canvas having been completed during that time. Painted in 1901, *Tahitian Woman with Children* has always been thought to represent a Tahitian woman and children rather than natives of the Marquesas Islands. There is no proof of this notion, and it is equally possible to relate the costumes of the figures – the only accurate indicator of place – with those painted by Gauguin in the Marquesas in 1902.

Wherever it was painted, this portrait has a deeply melancholic, haunting quality. It is saturated with blue – from the greenish blue of the abstract background to the deep blue of the woman's dress. While she appears too old to be the mother of the beautiful baby she is holding, her gentle, kind expression and the easy naturalness with which she and the children relate to one another indicate an intimate bond.

As is the case with many paintings Gauguin did in the South Seas, *Tahitian Woman with Children* is layered with Christian meaning. The infant could easily be associated with the Christ Child, and the dark spot on the young girl's left hand could refer to Christ's stigmata. From his first exposure to the moving, elemental religious art of Brittany, Gauguin had filled his art with Christian references, which were restimulated in the context of the earthly "paradise" of the South Pacific.

One wonders, given the traditional association of the figures depicted here with Tahitians, whether the woman, with her prominent wedding ring, is Gauguin's Tahitian wife Pahua and whether the children are his illegitimate offspring. There is no evidence to support such a claim, yet it is not improbable. We know from his letters to his European family and friends that Gauguin felt guilty about his abandonment of his five children with his Danish wife, Mette. Since this is the only portrait he produced in 1901, it is probable that he painted it for personal reasons. Perhaps, Gauguin wanted to take the image of his Tahitian family with him, as he went even further into exile.

Edvard Munch
Nude with Red Hair: Sin
1901

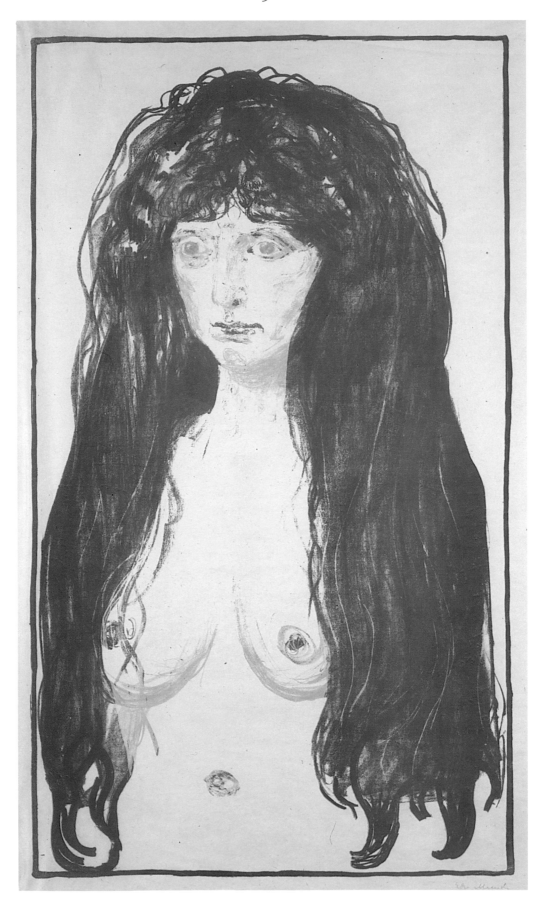

An artist more cosmopolitan than Edvard Munch is difficult to imagine. Fluent in several languages, he lived in Denmark, France, and Germany, in addition to his native Norway, and is the only Scandinavian artist of the nineteenth century who made a decisive impact upon world art. Even in his earliest paintings from the 1880s done under the influence of the greatest Scandinavian Impressionist, Frits Thaulow, there is an undeniable melancholy that anticipates his mature, Symbolist works.

Although Munch was an accomplished painter, most of his painted oeuvre remains in Norwegian collections, and he is known mainly in the United States and much of Europe for his prints. Indeed, he was as great a printmaker as he was a painter and mastered all three of the traditional printmaking mediums – etching, lithography, and woodcut. Like Gauguin, whose revolutionary prints (pp. 72-73) he saw at several points in his career, he made prints after paintings, in part to disseminate his powerful images to a wider public. He worked both alone and with professional printers to achieve individual impressions that are, in certain cases, as large and powerful as the paintings that inspired them.

The Art Institute of Chicago has one of the largest collections of Munch prints outside Norway, and the choice of this splendid lithograph, *Nude with Red Hair: Sin*, can only hint at the immense riches available in the museum's Department of Prints and Drawings. Printed in 1901, this lithograph was executed on three stones, in brown-red, yellow, and green. Together, the colors combine to form the head and upper torso of a young, but mature, woman with a glorious head of reddish brown hair. Munch subtitled this print *Sin*, encouraging the viewer to think of this figure not just as a nude, but as the primal Eve who led man astray. Her heavy hair hangs over her shoulders, obscuring her arms and hands and framing her face and breasts. Her face is at once terrifying and terrified. Her eyes are opened wide, but she stares blankly, as if caught in an intense bewilderment. Despite the tyranny she is supposed to exert over the male, our sympathies are evoked by this haunting figure, trapped so eternally and painfully by her passion. Whether she is a personification of sin, as her red hair suggests, or its victim, we will never know.

Edouard Vuillard
Landscape: Window Overlooking the Woods
1899

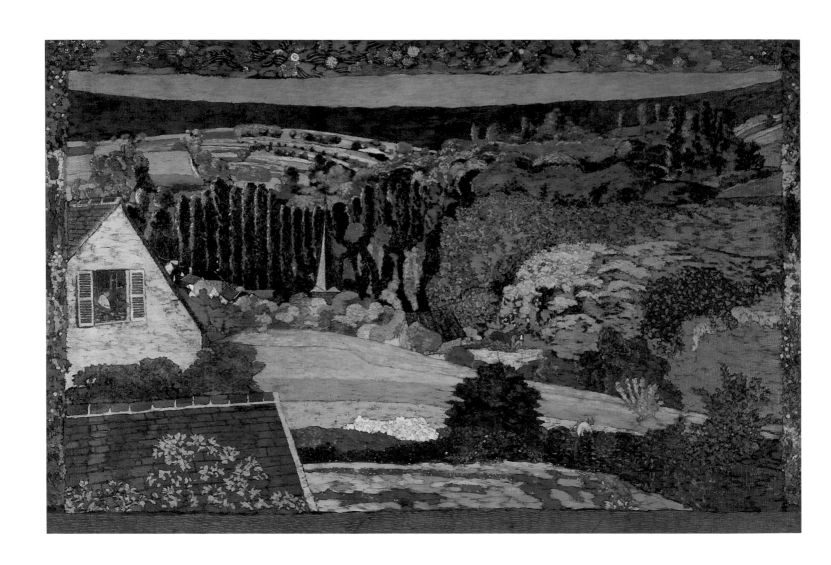

Although much less known today than his contemporary Henri Matisse, Edouard Vuillard was among the most advanced and accomplished artists of his generation. Already at twenty-two, he had achieved a reputation among a circle of young writers, artists, and musicians whose aesthetic ideas showed the influence of the Symbolist and Synthetist theories of Stephane Mallarmé, Paul Gauguin, and Claude Debussy. Like many artists whose careers began after the last Impressionist exhibition, in 1886, Vuillard experimented with the decorative arts and found an interested public for his lithographs, painted porcelain, stained-glass window designs, stage decors, book illustrations, and other alternatives to easel painting. However, most important for his earliest career were the commissions for large-scale paintings he received from members of his immediate social circle to decorate their urban apartment interiors.

The Art Institute is fortunate to have a stunning example of Vuillard's work as a painter-decorator in the monumental painting *Landscape: Window Overlooking the Woods*. It was originally part of a decorative ensemble with its pendant, *The First Fruits* (Norton Simon Museum, Pasadena), in the Parisian apartment of Adam Natanson. His sons, Alexandre, Thadée, and Alfred, commissioned Vuillard's first lithographs for their important literary magazine, *La Revue Blanche*, and gave him his first one-man show. This vast (12 x 9 feet) landscape painting was the third and last major project the artist executed for this family of enterprising men of letters.

In the Art Institute's painting, Vuillard extended the decorative potential of traditional landscape painting by transposing landscape into ornament. The landscape itself is conceived in massive, horizontal bands of lush, variegated greens that are accented by the verticals of poplars, rooftops, and a church steeple. Instead of creating an image one can imagine walking into, Vuillard framed his composition in a decorative border that redefines the viewer's relationship to the landscape realm. The border and the broad patches of color owe much to woven tapestry designs, especially Flemish landscape tapestries of the late sixteenth and early seventeenth centuries. However, in this painting, Vuillard refrained from exaggerated stylization and the simplification of landscape elements. Indeed, *Landscape: Window Overlooking the Woods* is grounded in his appreciative observation of a real place; the rolling hills, white-washed houses, and rustic church seen here can still be found in a western suburb of Paris where he spent many a Sunday in the company of his sister and brother-in-law, the painter Ker Xavier Roussel.

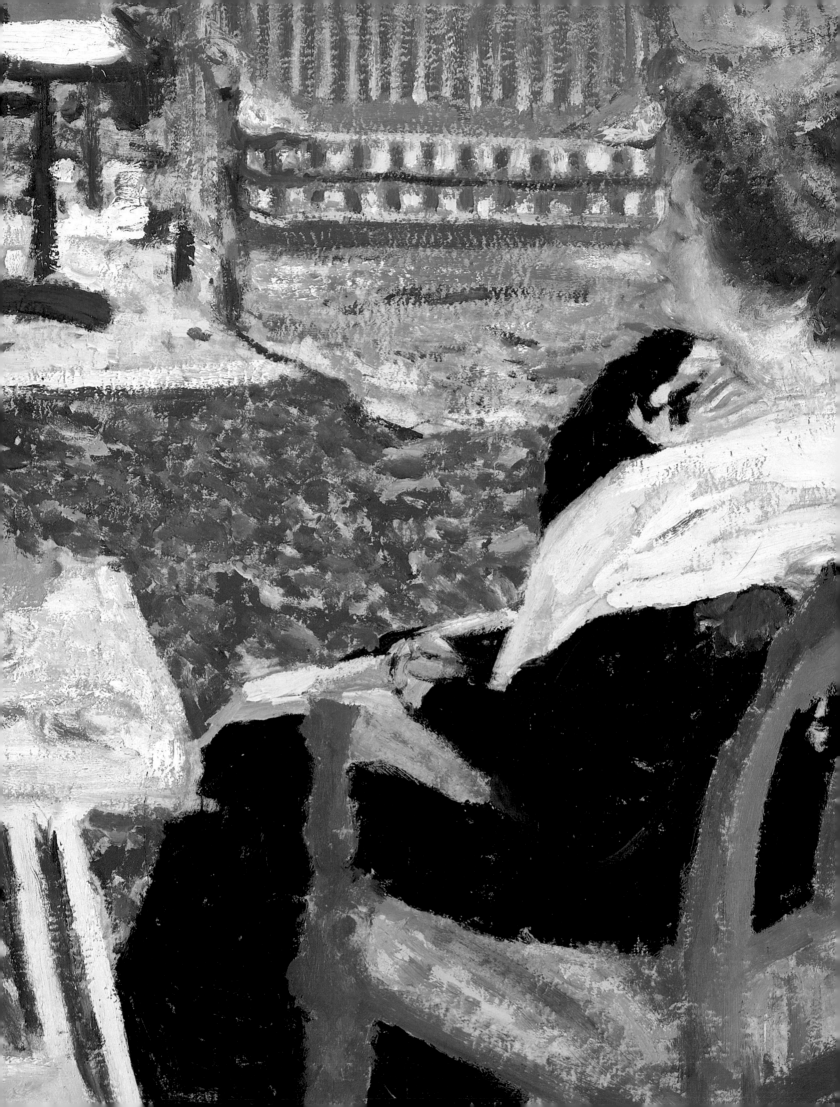

THE INTERIORS OF THE NABIS

The Impressionists concentrated their attention on the outdoors, and the atmosphere of their paintings is one of fresh air and space filled with strollers, boaters, and bathers. By contrast, the most advanced painters working in Paris during the 1890s were preoccupied with interior scenes, at night as well as during the day. Whether they are the depictions of the brothels and dance halls of Henri de Toulouse-Lautrec (see pp. 27, 44) or the domestic interiors of Edouard Vuillard and Pierre Bonnard, their paintings, drawings, and prints represent a bounded, urban world. Even when they ventured to work out-of-doors, they painted walled gardens and tiny, enclosed streets rather than the fields and rivers of suburban and rural France and the parks and boulevards of Impressionist Paris.

Vuillard and Bonnard were part of a group of artists who banded together in the 1890s and called themselves the Nabis, from the Hebrew word for prophet. The Nabis were a kind of private club with a small membership and vaguely mystical tenets. Bonnard and Vuillard, together with their lesser-known colleagues Félix Vallotton and Ker Xavier Roussel, gradually turned away from the mysticism of the original membership toward a careful, even painstaking, transcription of the private worlds of their friends and families. Although their paintings were usually given generic titles when they were exhibited, they represent actual rooms with specific people. Perhaps, for that reason, they were called Intimists.

The greatest illustrator of the 1890s in Paris was Vallotton, perhaps the least well known of these artists. Born in Switzerland, he began his career in Paris as an illustrator, eventually working for the famous avant-garde journal *La Revue Blanche*. His stark, black-and-white prints for this magazine represent, in highly controlled, stylized patterns, everything from domestic interiors to street fights and murders. Like most artists of the period, he wanted to be a painter, and he considered his magazine work a financial necessity. In 1899, he married a wealthy widow many years his senior, Gabrielle Rodriguez, daughter of the great Parisian picture dealer Alexandre Bernheim-Jeune. Her family money provided the economic cushion he needed to devote himself to painting.

Madame Vallotton and her Niece Germaine Aghion is among the best and earliest of his paintings and among the few in American museums. (Most works by Vallotton hang in Swiss museums or in the homes of the descendants of the Swiss and French collectors for whom they were painted.) The Art Institute's painting represents the artist's wife and her infant niece in a bedroom of the Vallotton's luxurious apartment in Paris. The seated woman seems totally absorbed in watching the tiny child tear pieces of paper and scatter them, like flower petals, across the patterned carpet. The child's blond hair and light pink outfit are notes of purity in a composition whose deep reds, from the burgundy of the bed and woman's dress to the carmine of the walls, must have suggested to the artist a mature, womblike enclosure. Without the title, one would never know that this is not a mother and her child. Madame Vallotton had teen-age children from her first marriage; she and Vallotton never had children of their own. Thus, the connection in this painting between the woman and infant, and, at the same time, their isolation from one another are charged with private meanings.

Although the work of Vuillard occasionally approaches the psychic power of Vallotton, it tends,

more often than not, to be a cooler, less intense, viewing of this upper middle-class domestic world. The Art Institute's paintings by Vuillard are among the hundreds of carefully wrought interiors the artist depicted in the 1890s and in the first decade of the twentieth century. Unlike Vallotton, who worked in large areas of pure color and smooth, evenly painted pictorial surfaces, Vuillard preferred to depict patterned interiors described with broken, irregular, and highly textured surfaces. *Child in a Room* represents Vuillard's niece in a room at his sister's home in a western suburb of Paris. The little girl plays alone, but, the empty chair pointing out of the picture plane and draped with a shawl suggests the presence of her mother, who must just have moved somewhere nearby. The mood is sunny, open, and complete.

Interior with Seated Woman is more psychologically complex. The painting is centered on a woman in a black dress, Madame Arthur Fontaine. Married to a government minister, Madame Fontaine was a pianist and was familiar with the circle of musicians, writers, and artists in which Vuillard participated. It is significant that the artist chose not to emphasize the elegant appearance of this wealthy woman or the sumptuousness of her home. Borrowing a technique used by Edgar Degas, Mary Cassatt, and others, he placed the figure in the lower right corner of the composition in a chair tilted at an angle, which leads the eye into the cozy, domestic interior of a drawing room. While Madame Fontaine dominates this composition, everything else in the painting is, in the end, more interesting than she is. By employing here a spatial construction derived from Japanese prints, Vuillard allowed the brilliant oriental carpet and casual clutter of the interior to vibrate around the dark mass of the sitter, nearly turning the background of the picture into its subject. As is always the case with Vuillard, his sense of balance and control is masterful. The figure and interior are woven into a tapestry of paint and pattern that is at once ordinary and magical.

Félix Vallotton
Madame Vallotton and Her Niece Germaine Aghion
c. 1899/1900

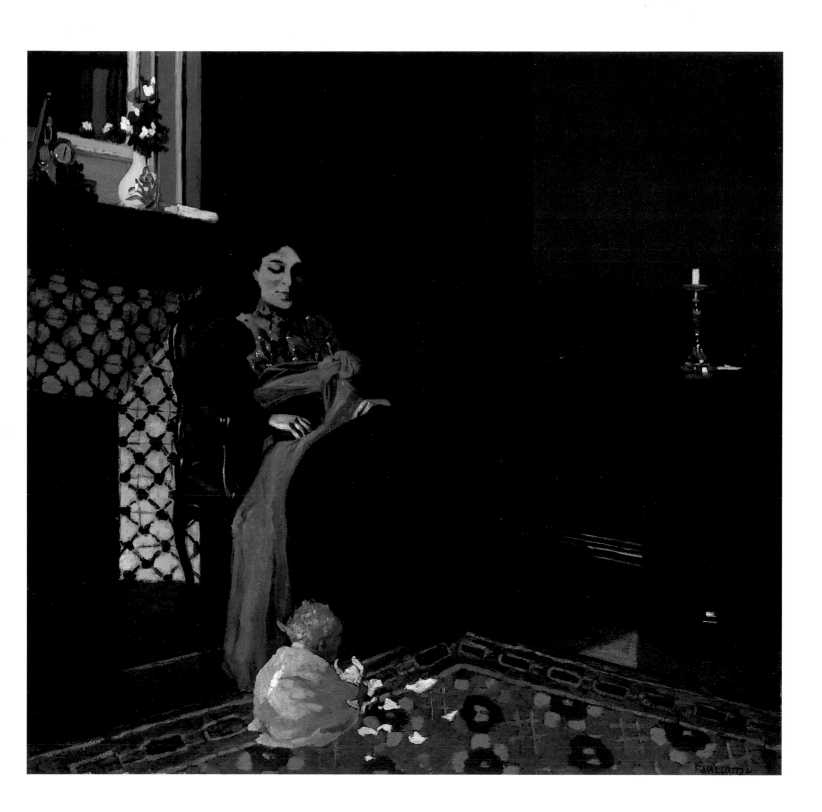

Edouard Vuillard
Child in a Room
c. 1900

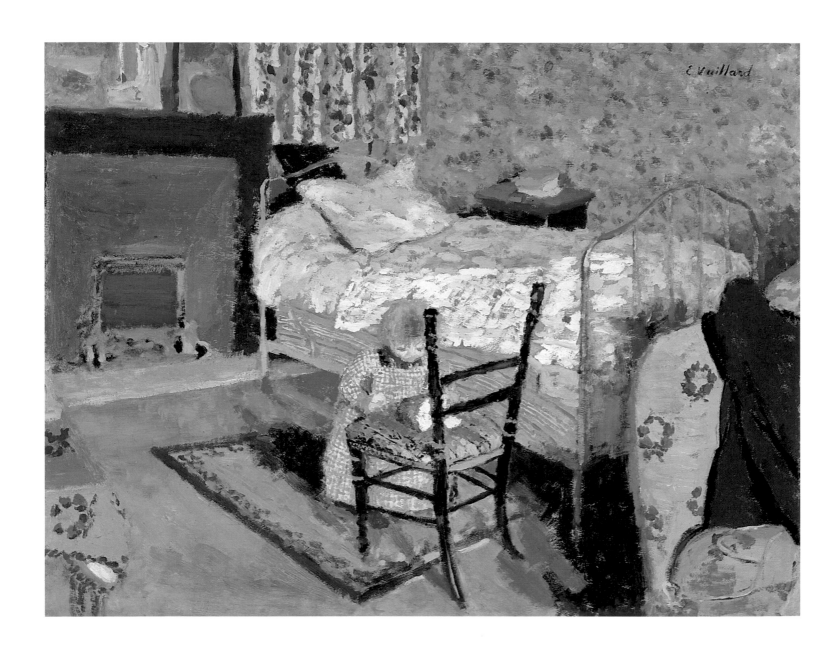

Edouard Vuillard
Interior with Seated Woman
c. 1904/05

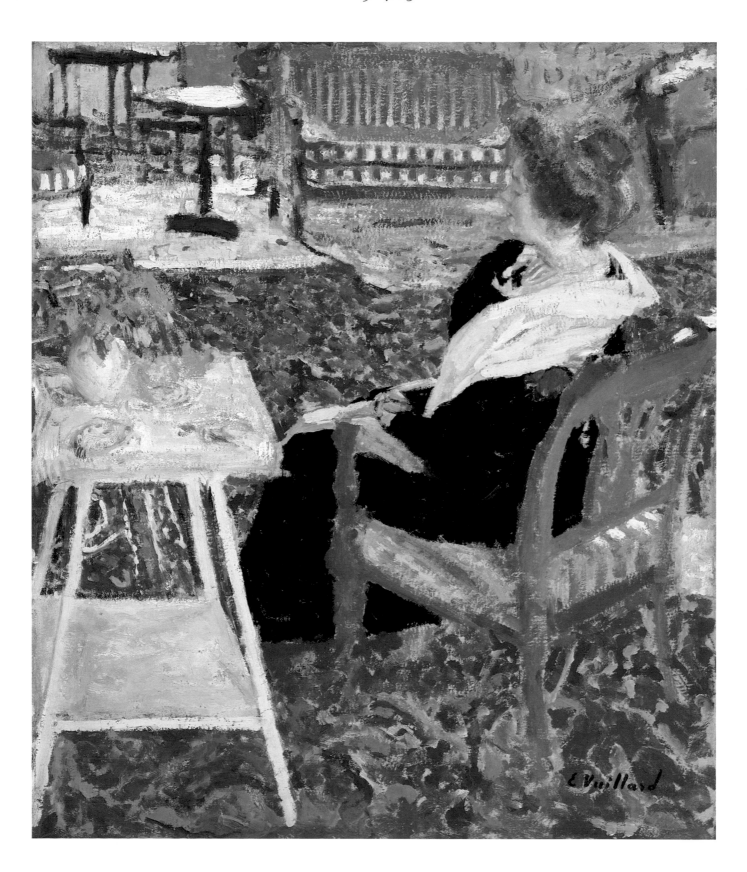

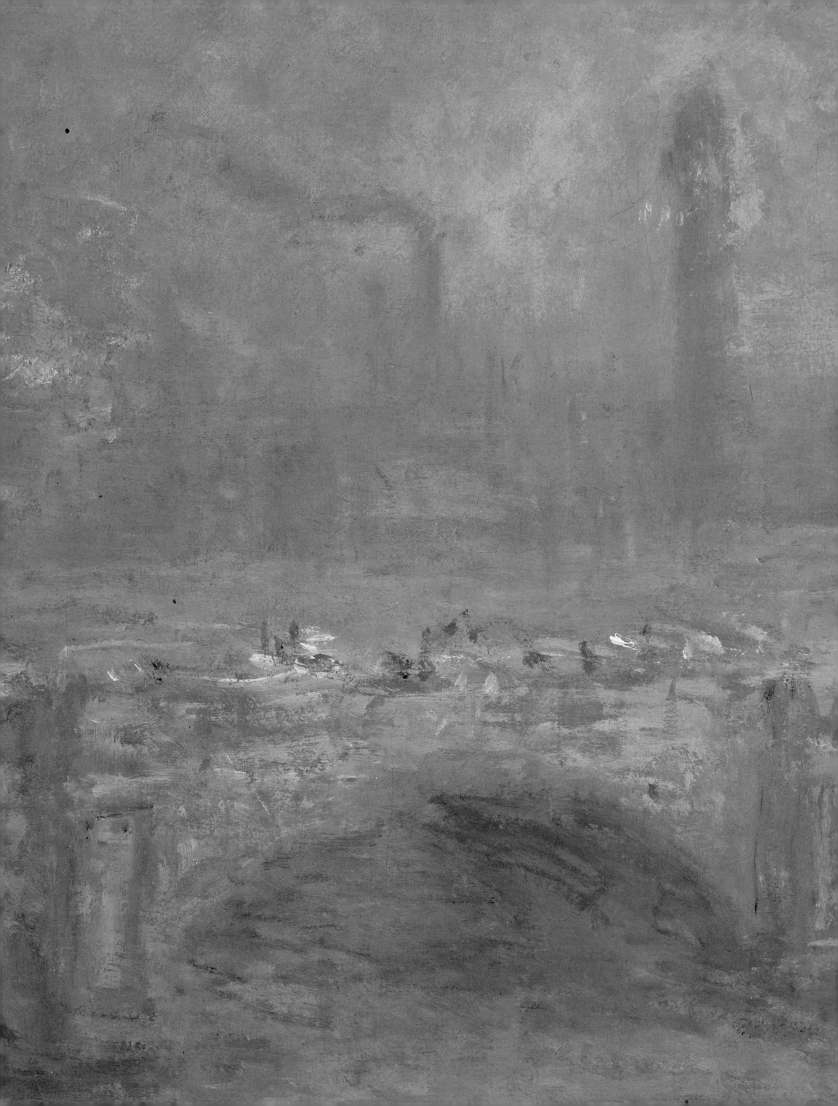

MONET'S LONDON SERIES

After completing his series devoted to the façade of the Rouen Cathedral and before beginning the monumental series inspired by his Japanese gardens at Giverny, Monet began work on a large group of paintings of the Thames River in London. In preparation for these, he made several trips to London in the winter months, during which he recorded and studied three motifs: the Waterloo and Charing Cross Bridges and the Houses of Parliament. "I love London," Monet wrote. "It is a mass, an ensemble, and it is so simple. Then, in London, what I love, above all, is the fog." So intent was he on capturing gradations of light as it is affected by fog that he undertook about one-hundred canvases. Of these, he finished thirty-seven, completed primarily in his Giverny studio.

In 1870, on his first trip to London, where he had fled during the Franco-Prussian War, Monet had painted the Thames and Westminster Abbey. The architecture of the latter he dissolved in mist – which suggests his appreciation at that time of J.M.W. Turner's evanescent visions and James McNeill Whistler's evocative city nightscapes, his *Nocturnes* of the same year. Five years later, he experimented further with effects of atmospheric haze, this time the steam of the trains at Saint Lazare station. By the time the fifty-eight-year-old artist began work on his ambitious group of London paintings, he had already decided to work in series by fixing his motif for a group of canvases and varying their temporal, chromatic, and atmospheric effects.

In the London series, Monet chose to create an ensemble of urban paintings, in which the movement of pedestrians and carriages, of trains and boats, gives way to the greater rhythms of light playing, through fog and mist, upon enduring architectural forms. He planted himself in the Savoy Hotel, from which he could see the Charing Cross Bridge to his right and the Waterloo Bridge to his left, and at the Saint Thomas hospital, from which he painted the Houses of Parliament. But, it was the London fog, in all its pervasive nebulousness, that became the artist's predominant theme. For Monet, it was the indefinable nature of the fog that transformed or, in *fin-de-siècle* terms, "dematerialized" the river, the great stone bridges, and the rugged contours of the Parliament buildings. These became essential forms that anchored his pictures during the five years he elaborated and corrected the works in his studio.

In these paintings, Monet showed even less concern for detail than in his previous series; with their reduced value contrasts, these works depend for effect on subtle transitions in hue. The Art Institute's *Houses of Parliament, Westminster* resembles a tissue-thin screen of shifting blues and pinks, suggesting the changing light of the sky through the fog and in the water's reflections. In *Charing Cross Bridge, London*, Monet succeeded in capturing the way in which a light fog can catch and disperse sunlight, transforming here the underlying pinks and blues into scrims of yellow. In the museum's two views of Waterloo Bridge, each with its sweep of smokestacks and buildings lining the riverbank, the artist reversed the lights and darks: in one, the bridge is a band of light; in the other, its dark shape is defined by the lighter water surrounding it. In both compositions, the city's life is indicated by dabs of paint that suggest the vague shapes and lights of a carriage, a small boat, smoke. Running through the paintings like a constant current, the city's energy becomes timeless in this series, which, more than any other up to this time, came from the depths of Monet's memory and imagination.

Claude Monet
Houses of Parliament, Westminster
1903

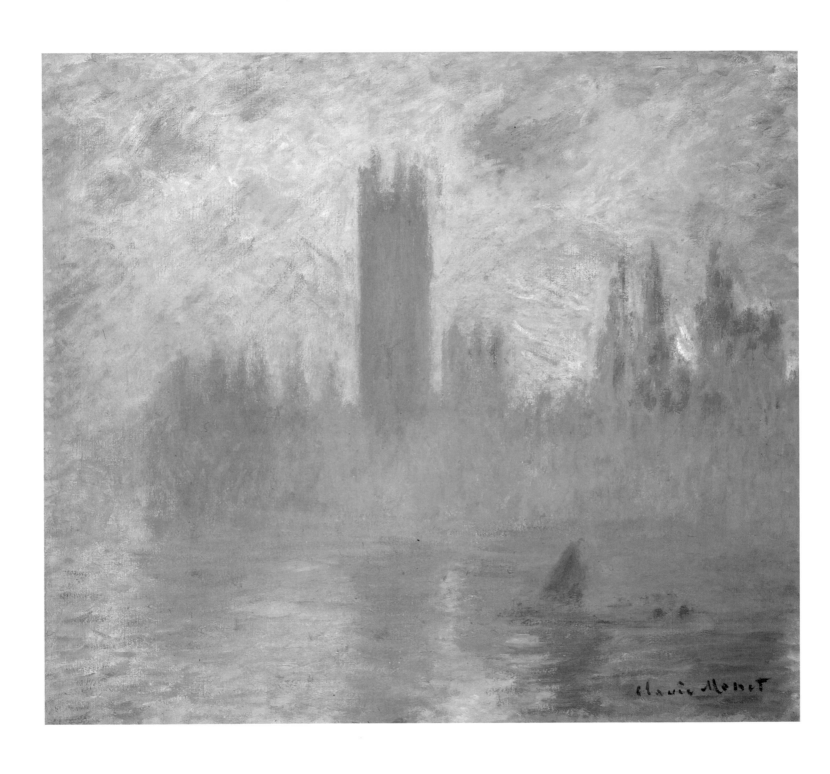

Claude Monet
Charing Cross Bridge, London

1901

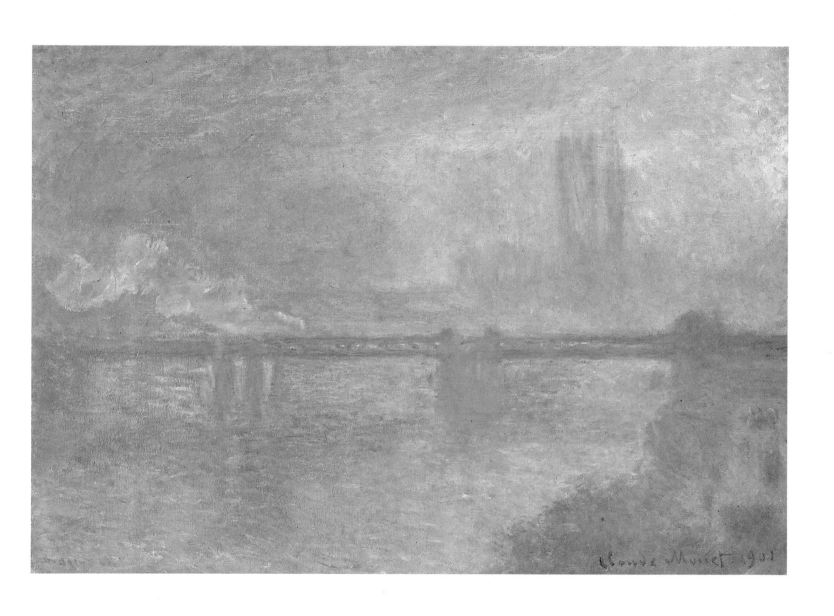

Claude Monet
Waterloo Bridge, Gray Weather
1900

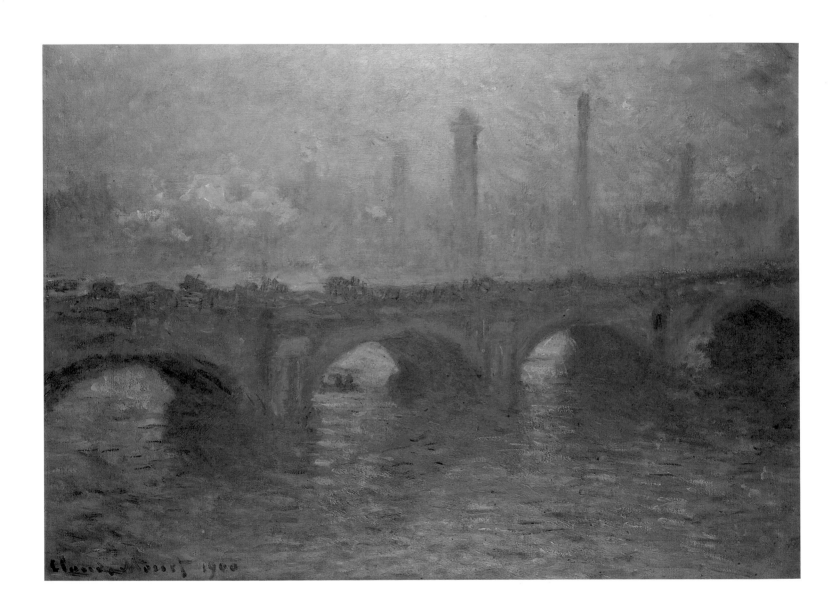

Claude Monet
Waterloo Bridge
1903

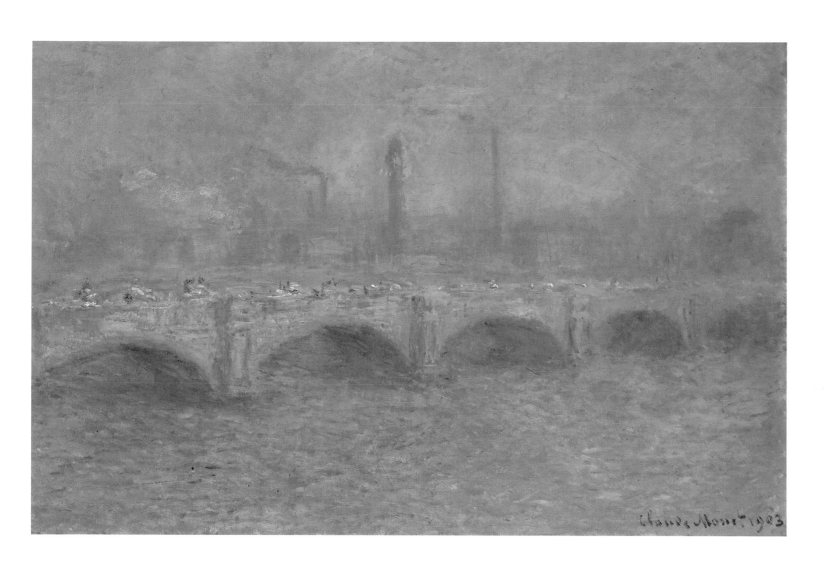

Edgar Degas
Woman at Her Toilette
c. 1895/1905

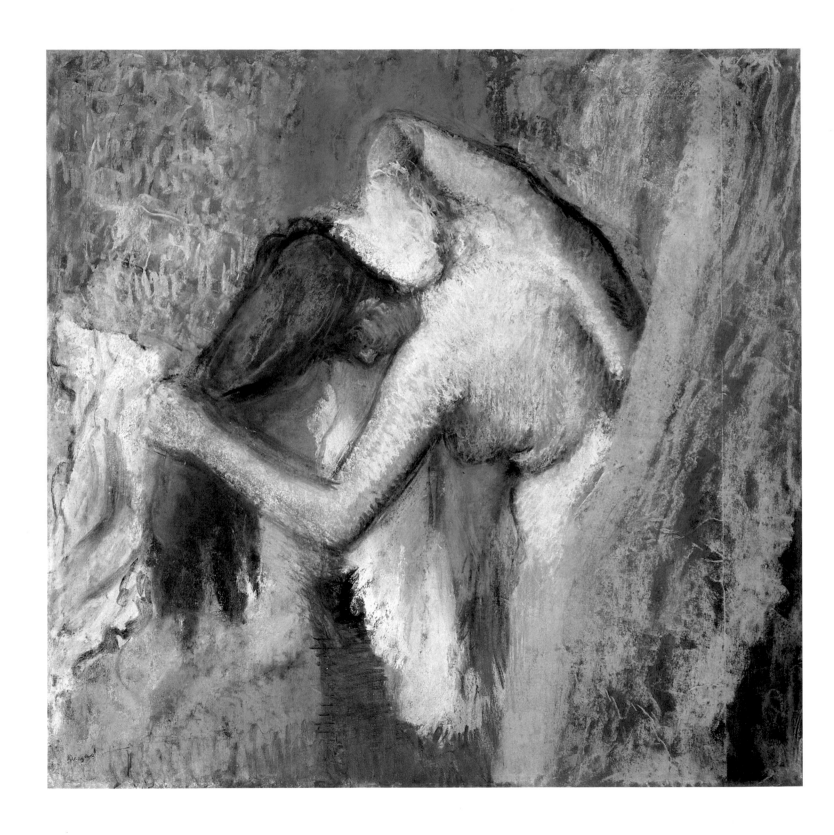

By the mid-1890s, Edgar Degas had virtually withdrawn from the artistic society of the Impressionists. He lived with an aging servant and worked, as his failing eyesight permitted, until his death in 1917. Unfortunately, he exhibited very little during this period and discouraged visitors to his studio, and it is therefore difficult to chart with precision the development of his career in his later years.

The Art Institute is fortunate to possess a large number of late works by Degas. *Woman at Her Toilette* is a fully resolved and complex pastel that is one of nine works with a figure in the same or a similar pose, each different than the last. We do not know whether Degas, moved perhaps by the example of Claude Monet's series (see pp. 36-39, 92-95), began to work in a similar way in the mid-1890s; unfortunately, he never exhibited these groups together. Yet, each work from his late years exists as one of a group of related works. Often, the relationship is direct, for Degas used tracing paper to borrow his figures from other works, sometimes transposing them in reverse and sometimes combining them with figures from different compositions. After he drew or traced the figure, he became involved with the setting, often adding strips of paper to one or more edges of the original traced drawing to create a larger work of art. Such is the case with *Woman at Her Toilette*, where Degas added three strips of paper to the left, right, and top of the original traced sheet containing the figure.

Woman at Her Toilette is alive with color. The hues range from red-oranges and salmon-pinks to pale greens and lilacs, a palette so wonderfully varied and masterfully balanced that even so great a colorist as Henri Matisse could hardly compete. Degas's approach to pastels was deeply inventive: he applied the pastels in layers, suspended them in fixatives, sponged them with solvents, and manipulated them almost alchemically. The resulting intermingled hues produce effects that vary greatly when the pastel is viewed from different distances. From fifteen feet or less, the salmon-pink curtain to the right of the figure is shot through with mustard-yellow and deep blood red, but these subtle hues disappear at a greater distance. The same is true for each element of the picture. Even the wet body of the woman seems to pulsate with the reflections of every hue in the environment. Indeed, the woman's body becomes a vortex, a whirling rainbow of color encircled by powerful juxtapositions of orange-blue and yellow-green. By covering the woman's buttocks with drapery, Degas effectively suspended her in color, denying the wholeness of her form. Here, the human figure barely survives the riot of pastel in which she exists.

Edgar Degas
Bathers
c. 1895/1905

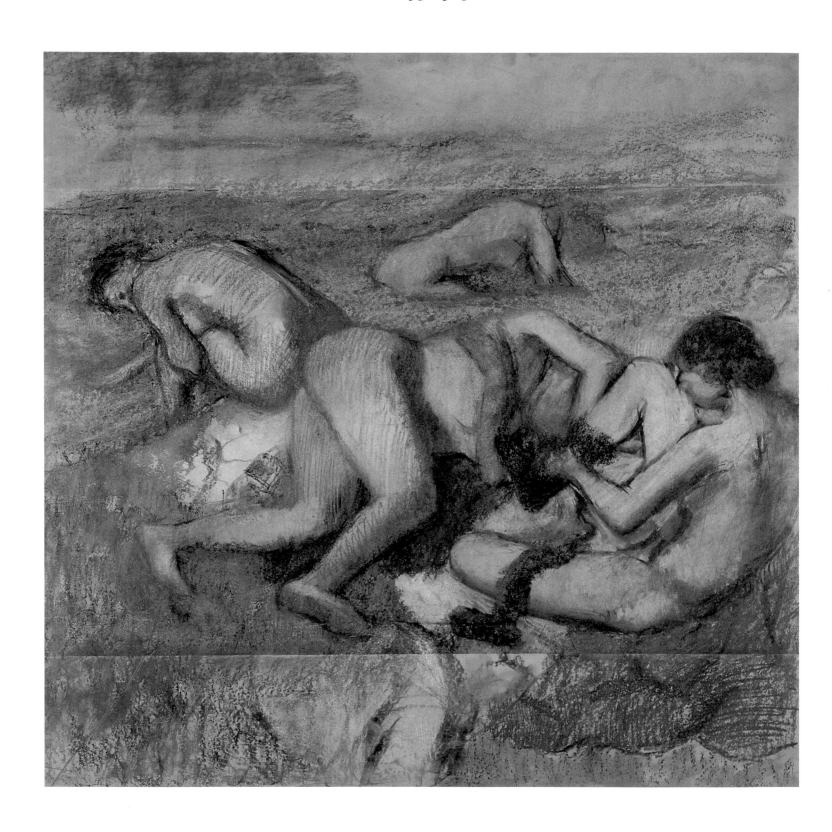

Virtually every great artist of the nineteenth century was attracted to the subject of female bathers, and, in early twentieth-century works by Picasso, Braque, Léger, and Matisse, the representation of the bather reached its apogee. Unlike most artists who chose this subject, Edgar Degas was interested more in the relatively modern and urban phenomenon of indoor bathing. Although he did exhibit an odd, and ambivalent, painting of peasant bathers in the Impressionist exhibitions of 1876 and 1877, he preferred to examine the female bather alone or with her maid in the privacy of her bathroom or boudoir. The idea of private moments haunted Degas throughout his career, and his bathers are no exception.

However, sometime in the mid-1890s, he began to represent groups of female bathers out-of-doors. The Art Institute of Chicago is fortunate to possess the most important and monumental work in this late group, *Bathers*. Although less fully realized than *Woman at Her Toilette* (p. 96) and despite the unevenness of its finish and the unintegrated strips of paper at top and bottom, *Bathers* is among the greatest of Degas's late works. Clearly, he was moved by the late bathers of Paul Cézanne (see p. 74) and the "primitive" nudes of Paul Gauguin. Unlike both these younger artists, Degas chose to make his largest

bathers with the most fragile of materials – tissue paper and pastel. For his subject, he chose four female bathers – one in the water, one partially in the water, one rolling inexplicably on the banks of the river, and one dressing or undressing. Each of them appears to have been borrowed by Degas from another work of art, and, although perfectly integrated into his composition, they are improbably related in psychological terms, for they seem almost oblivious to one another. The central figure derives from a bather in a painting by Cézanne owned by Degas; Gauguin's famous *Day of the Gods* (p. 60), also in Degas's collection, contains other similarly posed figures. The entire effect of Degas's collage of bathers is one of supreme artifice, and yet, the inclusion of socks on the nearest figure is a clear reference to his own historical era and, hence, to modernity.

Degas never exhibited any of the out-of-doors bathers during his lifetime, and he must have felt ambivalent about them. The settings of these works derive at once from his dreamy landscape monotypes and from the flats of scenery that fill his late paintings and pastels of the ballet. In *Bathers,* the effect is less actual than theatrical, with the improbable blue of the water together with the evanescent pinks and oranges of the landscape lending an aura of unreality to the pastel.

Ferdinand Hodler
James Vibert, Sculptor
1907

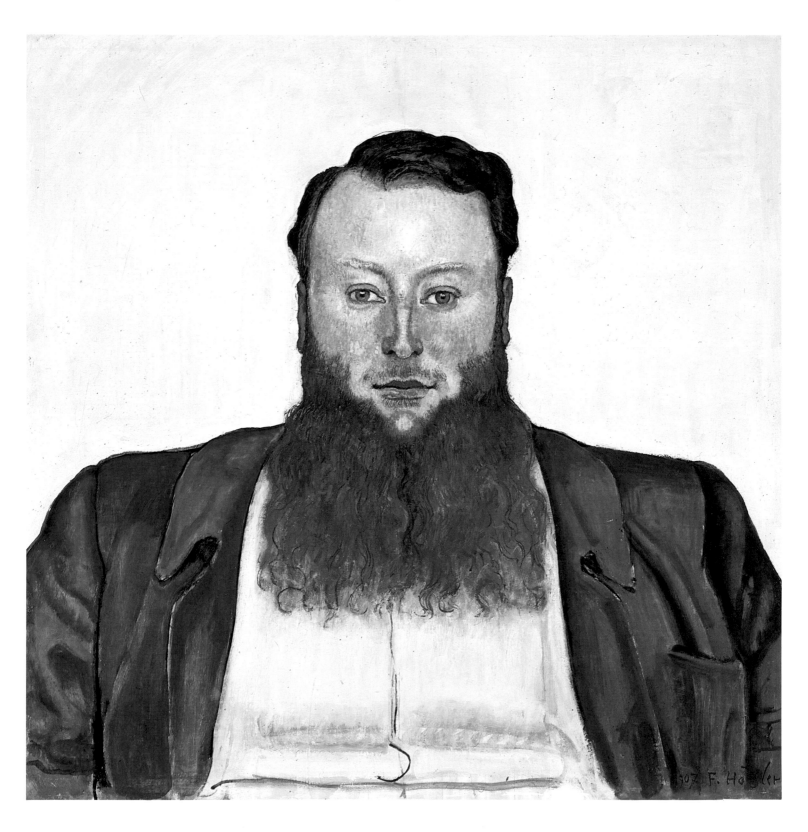

Ferdinand Hodler was, with Félix Vallotton, the crucial Swiss painter of the late nineteenth and early twentieth centuries. Like Vallotton, Hodler spent considerable periods of time in Paris. Yet, unlike his fellow countryman, he wanted very much to be a Swiss artist and, with several other of his compatriots, including the sculptor James Vibert, attempted to bring some of the energy and intensity of French aesthetic life to his native country. Very few important works by Hodler can be found outside Switzerland, where he is represented in major public and private collections. The Art Institute is fortunate to possess one of Hodler's finest portraits, depicting his friend James Vibert.

From an absolutely frontal position, the monumentally proportioned sculptor gazes at us with such directness that he seems to look right through us. Gone are the props or niceties of pose that habitually personalize a portrait. Instead, Vibert simply exists, his character condensed by Hodler into an almost iconic form created through an abstract language of painted lines and colors that conform to the artist's theory of art, which he called "parallelism." According to this theory, the painter has to obey certain laws – recognizing the flatness of the canvas, dividing it into geometric planes, drawing the contours of the subject with expressive clarity – in order to render the essential "unities of existence." Here, a strict symmetry is maintained, with the sculptor's head placed at the exact center of the composition, and the major features of the portrait – Vibert's face, beard, and clothing – aligned symmetrically along the canvas's midline. The rhythms of similar shapes, the imposing silhouette and mass of Vibert's body all give the picture an intensity that is as philosophical as it is physical, and this is made all the stronger by the fact that the sitter is not placed in a recognizable setting, but rather against a field of pulsating yellow paint.

For all its participation in Hodler's theory of "parallelism," his portrait of Vibert is, in the end, a portrait. An exactly contemporary description of the sculptor made without knowledge of Hodler's portrait makes the truth of the painting clear: "An energetic man – a man of action: his eyes are round and wide awake – his lips are closed and pinched, some might say. Without being large, he has a Herculean physique, large shoulders, and big biceps… his red and wavy beard succeeds in giving him a powerful and virile expression."

Ferdinand Hodler
The Grand Muveran
1912

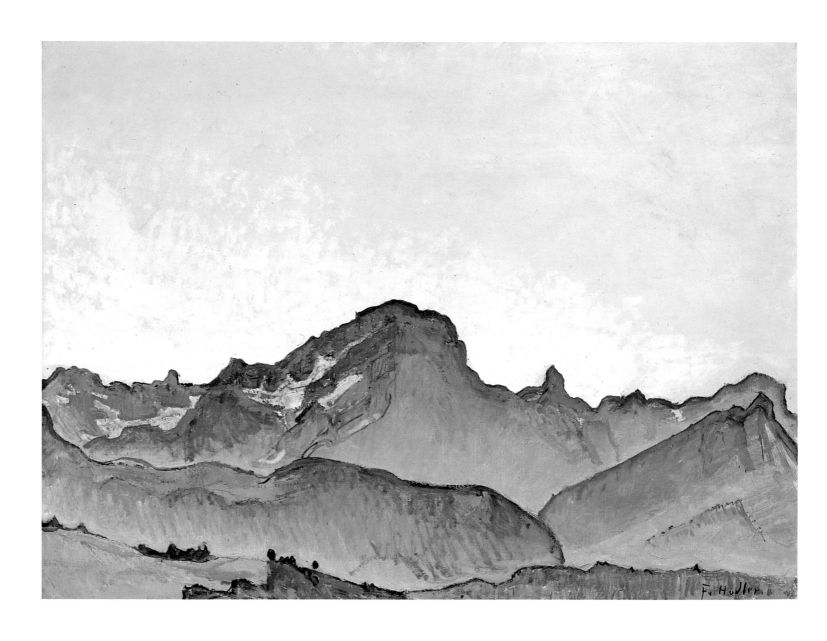

Perhaps because of the undisputed natural grandeur of his native Switzerland, Ferdinand Hodler was powerfully moved by nature's beauties and conceived a theory of art based on what he considered to be the great unities that underly the natural world. Many of his most important early paintings are landscapes, and, in spite of the fact that his largest, most ambitious works of art are figurative murals, his landscapes form the backbone of his oeuvre.

Born in the same year as Vincent van Gogh, Hodler responded to nature with much of the passionate intensity and emotionalism of the Dutch painter. Like the Post-Impressionists, Hodler seized the major features of a landscape and exaggerated their formal qualities. His colors are more intoxicating, his compositions simpler and clearer, his effects stronger than those experienced in nature itself. Indeed, his major achievement as a landscape painter was to have taken a famous, sublime landscape site associated with tourism and return it to nature.

In 1912, Hodler spent the year in a village called Chesières, in the Vais region of southern Switzerland. There, he made at least thirteen paintings of the Grand Muveran, the highest mountain in a chain of peaks that dominate the landscape of that region. One of the most beautiful of these compositions is in the Art Institute's collection. By removing from this painting any traces of human life, Hodler isolated the great chain of peaks and allowed it to fill the picture surface. The craggy, purple silhouette of the mountain and the lesser peaks leading up to it stretch across the canvas beneath an even larger expanse of yellow sky (on the back of the canvas's stretcher is written "morning impression"). The careful orchestration of colors, simplification of shapes, and interaction between earth and sky create a powerful impression of the immutability and lonely grandeur of the Swiss Alps that presages the mountain landscapes of such German Expressionists as Ernst Ludwig Kirchner and Gabriele Münter.

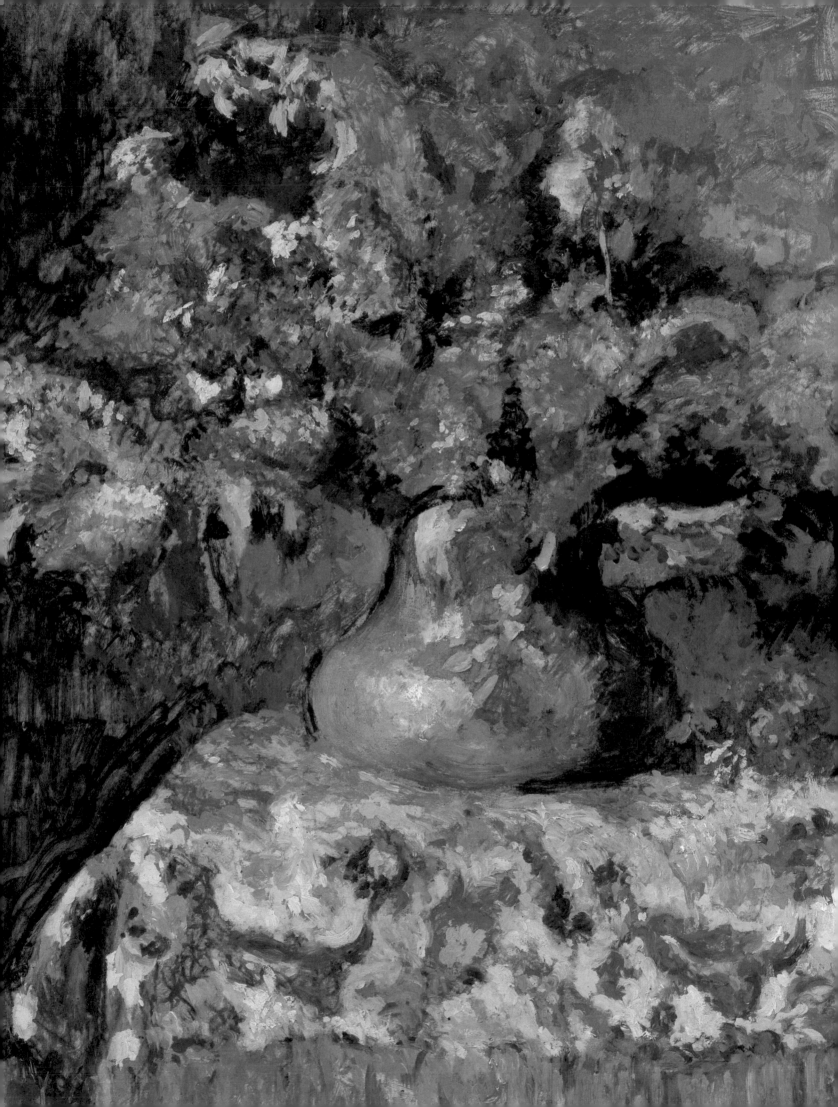

Flowers have always been a favorite subject of realist painters. In the seventeenth century, an entire genre of flower painting was established and certain artists devoted their careers to painting floral motifs. This tradition thrived in France through the eighteenth and into the early nineteenth centuries, when it was discouraged by its academic rating near the bottom of a hierarchy of genres that had history painting at its pinnacle. Perhaps, as part of the rebelliousness of nineteenth-century French artists against academic constraints, many great figure and landscape painters such as Delacroix, Courbet, Manet, Fantin-Latour, Renoir, Monet, and Cézanne made important floral still lifes, works that play essential roles in the history of what we now call modern painting.

It is, therefore, no surprise that flower painting figures so importantly in the careers of Odilon Redon, Edouard Vuillard, and Ker Xavier Roussel. Three examples of their paintings on this theme are represented on the pages that follow. None of these artists specialized in flower painting. Redon was a painter of Symbolist dream visions, Vuillard a transcriber of modern indoor life, and Roussel a maker of mythological decorations. Yet, each painted floral still lifes, both for pleasure and for easy sale. Possibly, because of the latter motivation, flower paintings still fail among critics and historians of art to find real appreciation – they seem too easy and somewhat commercial. However, because many of them were made for enjoyment, with little pressure on the artist to make an important statement, they can also be interpreted as critical indicators of an artist's private sensibilities.

The latest of the three floral still lifes shown on the next pages might just as well be the earliest because it is the work of the oldest artist. It was painted in 1910 by Redon, who had turned to color only in 1895, at the age of fifty-nine, after having been an artist exclusively of black-and-white visionary prints and drawings. By the mid-1890s, under the undeniable, but unadmitted, influence of younger artists, Redon fell prey to the seduction of color and began to make pastels and oil paintings that are among the most brilliant and evocative of the decade. During these years, he used his earlier contact with the great French botanist Armand Clavaud to create small symphonies of color using flowers. For Redon, images of flower arrangements were a matter of pure color and form. He used the most brilliant of nature's own colored shapes, arranged them in various simple vases, and represented them against gently colored, undefined backgrounds that bear no apparent relationship to reality. Even when Redon worked from actual motifs, like flowers, there is a haunting, poetic unreality about them, created by the jewellike quality of his color palette and the rich, silky texture of his surfaces. In the Art Institute's oil painting, this effect is reinforced by the way in which the flowers seem to float over and fill the upper left quadrant of the painting with no apparent shift in balance on the part of the wonderfully painted vase, whose translucent surface decoration radiates all the colors of the bouquet above.

Both Vuillard and his brother-in-law, Roussel, were more direct in their transcriptions of flowers. Roussel's resplendent *Flowers* may have been one of his entries to the 1905 Salon d'Automne, where he exhibited three floral still lifes. The monumental composition is simple and straightforward, the vase of flowers occupying the center of the pictorial field. What fascinated Roussel were the subtle hues of the

purple lilacs and small yellow flowers. To capture these trembling forms, he created delicate colored glazes by applying layer upon layer of thinned pigment. The rich texture of the purple and green dotted with spots of gold recalls the arresting floral compositions of Henri Fantin-Latour and Frédéric Bazille. But, Roussel did not isolate his flowers against a solid, somber background, as the older artists typically did. Instead, he juxtaposed them with the exuberant designs of the wallpaper and ceramics on the wall behind them, the paisley print of the fringed cloth under them, and the deep, vigorously defined shadows they cast around them, resulting in a shimmering surface of color and pattern, light and dark.

Vuillard's composition of snowballs in a glass vase is, in some ways, the most complex of the three paintings. *Still Life (Snowballs)*, a deceptively simple arrangement of silvery whites, blues, greens, and yellows, can be read as a pictorial poem about the nature of art, using flowers as the central motif. We see the flowers twice – on the mantelpiece and in the mirror that hung on the wall over it in the painter's Parisian studio on the Boulevard Malesherbes. The mirror also reveals to us a work of art and a trademark of Vuillard's studio, a plaster cast of the torso of the famed Venus de Milo in the Musée du Louvre, Paris, which he incorporated as a kind of muse or model into many other works. The marble of the mantel and the reflected sculpture interact in ways analogous to the real and reflected snowballs. And, when we realize that even the word "snowball" (the same in English and French) evokes images of winter that are the opposite of the flowers, this painting takes on additional meanings. Where Redon and Roussel painted flowers for their color and form, Vuillard involved them here in a strategic dialogue between life and art.

Odilon Redon
Still Life: Vase with Flowers
C. 1910

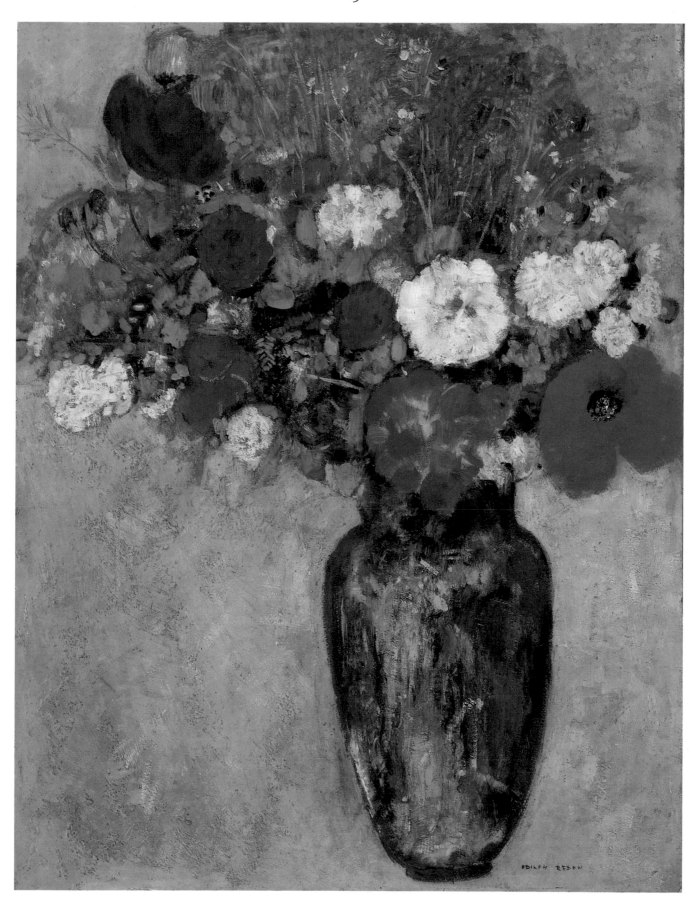

Ker Xavier Roussel
Flowers
1904

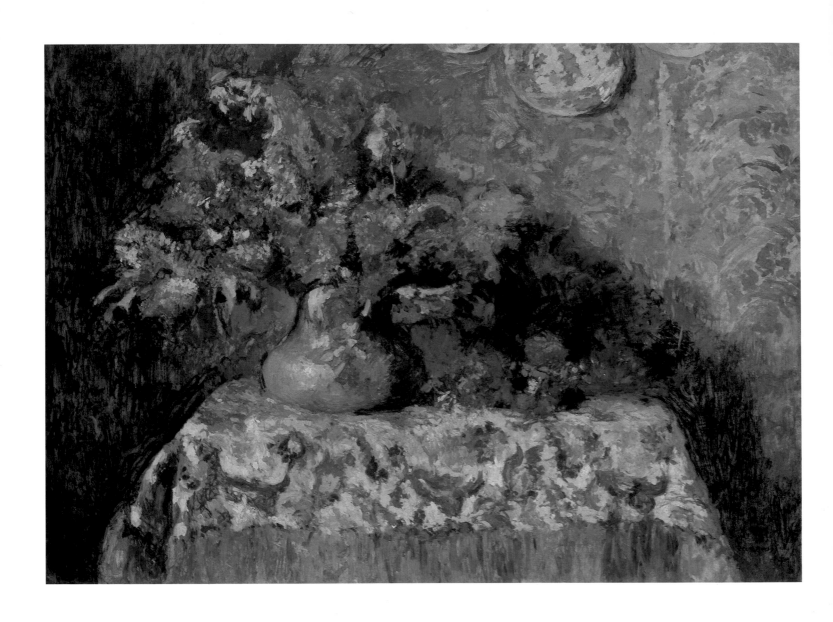

Edouard Vuillard
Still Life (Snowballs)
1905

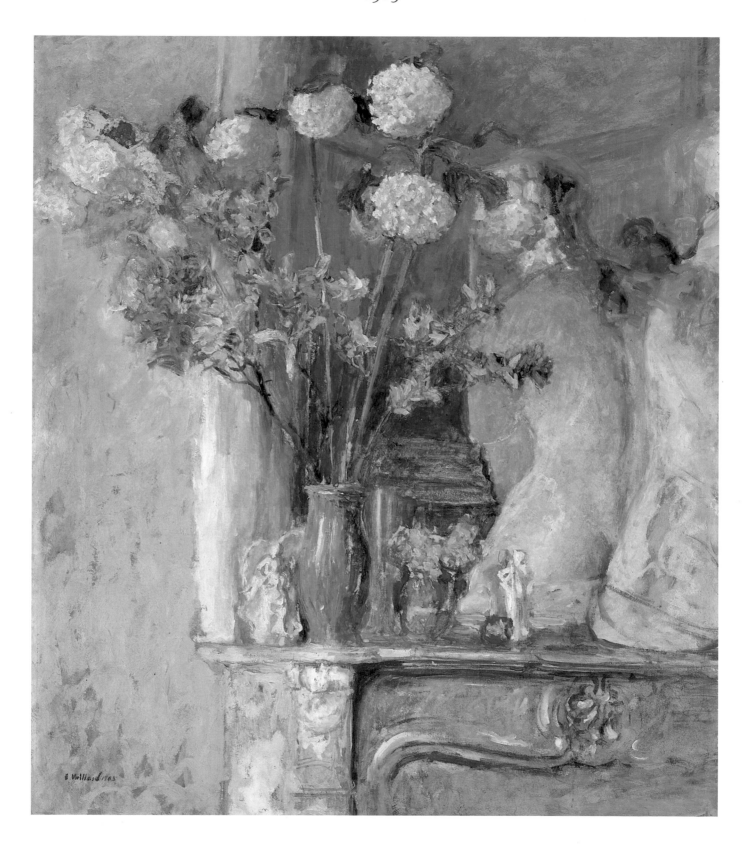

MONET'S WATER LANDSCAPES

Twentieth-century art is inconceivable without Claude Monet's paintings of water lilies. They are, in many ways, as important in the history of artistic invention as the Analytic Cubism of Pablo Picasso and Georges Braque or the decorative abstraction of Henri Matisse. Painted between 1899 and the painter's death in 1926, they are among the greatest "late" works in the history of art, rivaling those of Titian, Rembrandt, Chardin, and Cézanne as landmarks in the history of easel painting. Monet himself was aware of the importance of his paintings of water lilies and contributed a good deal to our understanding of them. Indeed, he was obsessed by these paintings, which he called "water landscapes," and he painted little else during the last twenty-five years of his life.

Monet moved to his long, rustic farmhouse in Giverny in 1883. In 1890, he acquired more property and devoted himself to creating out of it an ideal garden, as distinct from the real, rural subjects he had painted and continued to paint until 1900. The garden was divided into two major parts: the flower garden near the house, and, in a swampy field, the water garden created by diverting a tributary of the Epte River. The flower garden was arranged in a rectilinear pattern of paths, while the water garden was completely curvilinear, encircling a peanut-shaped pond with a Japanese footbridge at the narrow focal point. The flower garden was useful as well as beautiful, providing flowers for the house and studio. The water garden's only purpose was to be beautiful.

The earliest series of water landscapes was painted in 1899 and 1900 and represents the Japanese footbridge from the larger end of the pond. In these paintings, including the Art Institute's *Pool of Water-Lilies*, water lilies cover most of the surface of the pond and leave only small areas for actual reflections. The pictorial space of these early paintings is conventional – the horizon line is clearly fixed so that the water takes up the lower half of the pictorial field, while the bridge and trees that dominate the upper half act as a point of reference that makes the remainder of the space in the sunlit pool legible. These early water landscapes are bounded by trees at the end of the pool, keeping the viewer within the confines of Monet's ideal world.

Monet became less and less concerned with conventional pictorial space in his transcription of the water garden. By 1904, the horizon line of the water landscapes had crept to the very top of the canvas, and, by 1906, when *Water Lilies* was painted, there was no horizon line at all. For Monet, the subject of the paintings increasingly became the surface of the water. At once a mirror of the world above and a window into the world within the pool, Monet's illusionistic surface was in every sense the ultimate pictorial surface.

Monet's paintings of his water garden did not follow a clear progression from conventional landscapes to radical treatments of the surface of both pond and canvas. Monet worked in fits and starts. Sometimes, his eyes troubled him, and he was unable to see correctly. At other times, he was overcome by bouts of depression, boredom, or self-doubt. These had a dramatic effect on his work. We know, for example, that he started a good many more paintings than he finished in his latter years and that he also destroyed works of art because of what he perceived to be their failures. In fact, the painter destroyed at least fifteen major paintings of the water garden just before they were to be exhibited at the Durand-Ruel gallery in Paris in 1908. Few painters of his genera-

tion demanded as much of their paintings as did Monet.

Monet's aim was not solely to create a viable pictorial surface. By 1910, he had transcended the conventional boundaries of easel painting and had begun to create immense decorations that culminated in the series of water lilies commissioned by the French government for two oval galleries in the Orangerie. Monet began the series in 1916 and worked on it until his death, creating a number of huge triptychs and other groups of canvases designed to be seen together. No longer was the painter interested in decorative series. Rather, he created immense, unified decorations.

The importance of these paintings cannot be overestimated. They were created at a time in the history of western painting when the conventions of representation, either of solid bodies in space or of illusionistic landscape space, were under scrutiny. It is amazing to be reminded that these canvases were painted nearly four years before Analytical Cubism changed forever concepts of the solidity of the figure in pictorial space, proving that the elderly Monet was as much a radical as the young Picasso or Braque.

The remarkable aspect of Monet's late decorative painting is its facture – the rugged, almost pockmarked surface that Monet had developed by 1916. The hearty spring flowers in *Iris by the Pond* emanate from a surface so complex and dense that it resembles a roughened plaster wall. Gone is the subtle interplay between the canvas and the painter's marks that was such an important part of Impressionist painting. Never completed, *Iris by the Pond* was in Monet's studio at the time of his death in 1926. Unlike many of his late canvases, it was not finished by another hand to make it saleable. Hence, when we stand before it, we can experience with remarkable authenticity the inner workings of the artist's mind as he struggled to push painting to a new, transcendent realm.

Claude Monet
Iris by the Pond
c. 1919/25

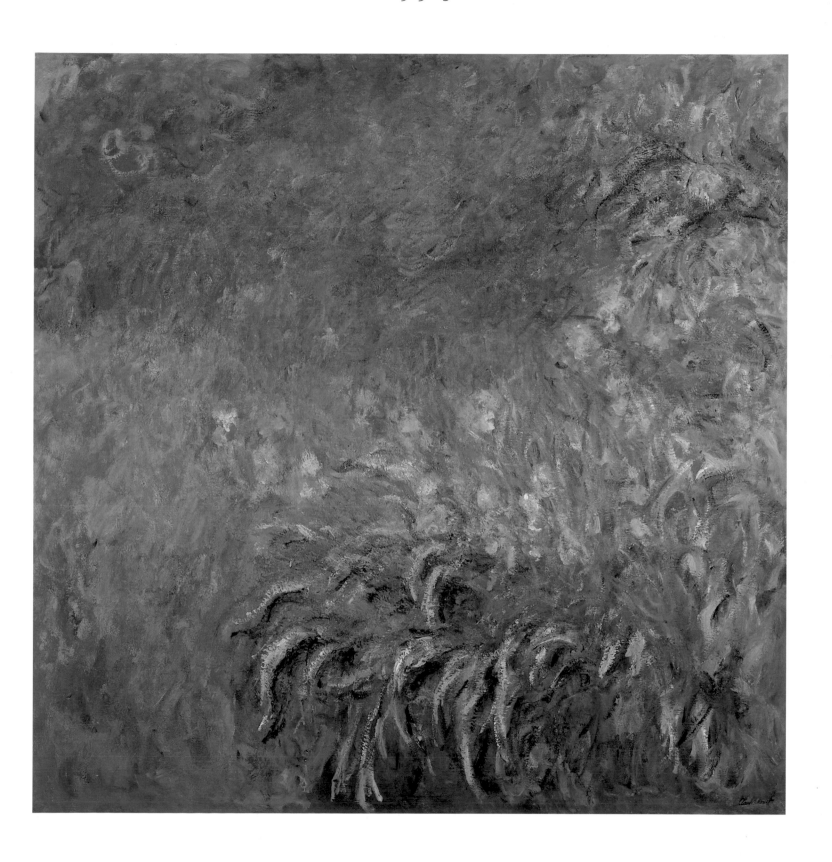

Claude Monet
Pool of Water Lilies
1900

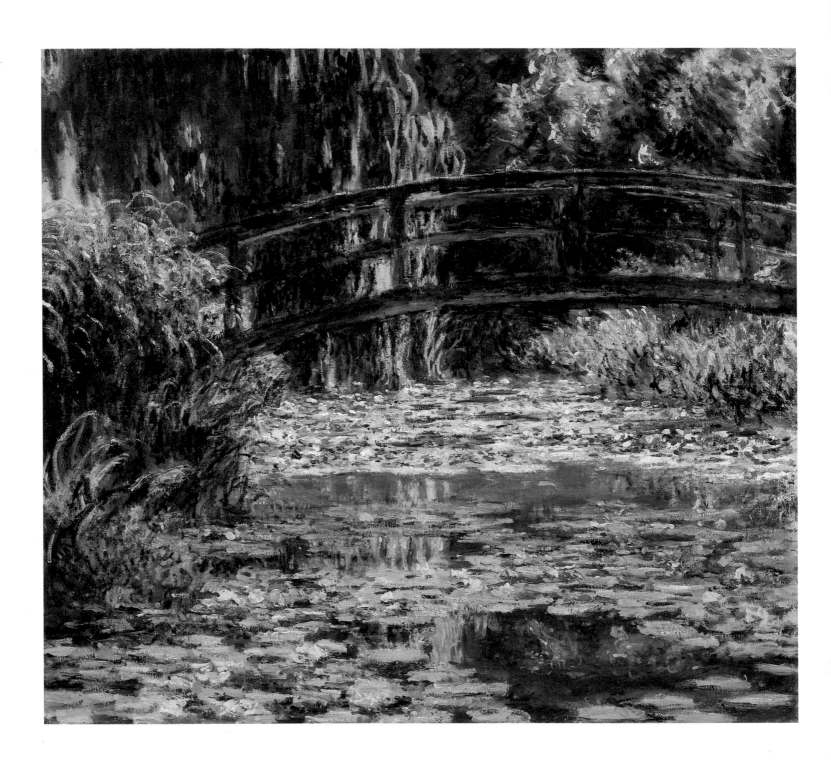

Claude Monet
Water Lilies
1906

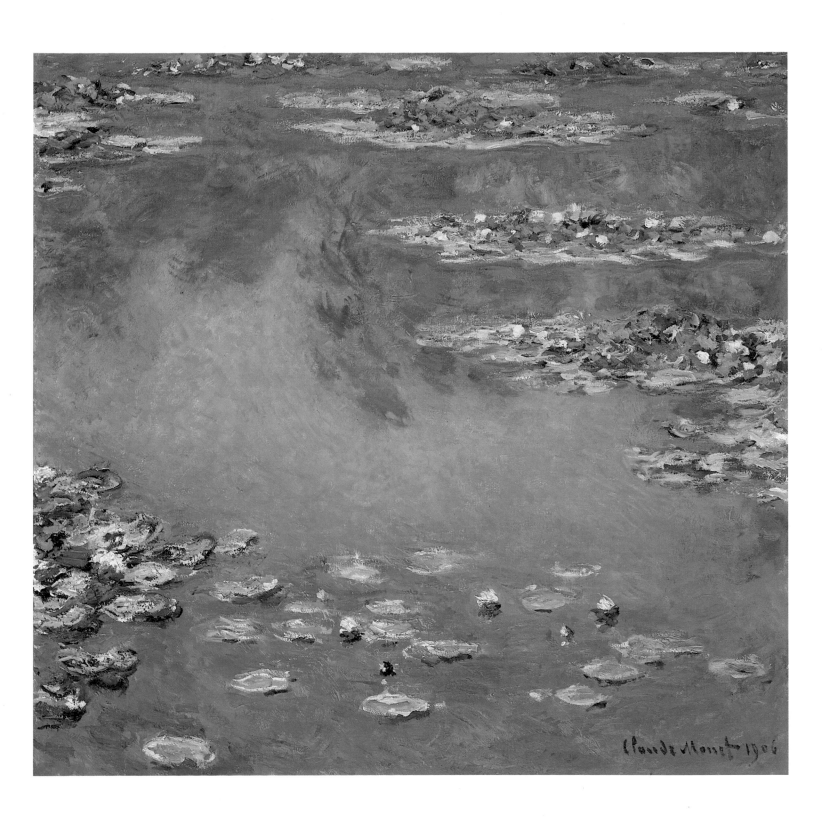

CHECKLIST

Cézanne, Paul
1839-1906

Vase of Tulips
c. 1890/92
Oil on canvas, 59.6 x 42.3 cm
Mr. and Mrs. Lewis Larned Coburn
Memorial Collection, 1933.423
pp. 32 (ill.), 33

*The Bay of Marseilles,
Seen from L'Estaque*
c. 1886/90
Oil on canvas, 80.2 x 100.6 cm
Mr. and Mrs. Martin A. Ryerson Collection,
1933.1116
pp. 40 (det.), 41-42, 43 (ill.)

*Madame Cézanne
in a Yellow Armchair*
c. 1893/95
Oil on canvas, 80.9 x 64.9 cm
Wilson L. Mead Fund, 1948.54
pp. 64 (ill.), 65

Basket of Apples
c. 1895
Oil on canvas, 65 x 80 cm
Helen Birch Bartlett Memorial Collection,
1926.252
pp. 66 (ill.), 67

Bathers
c. 1899/1904
Oil on canvas, 22.6 x 35.4 cm
Gift of Mrs. Clifford Rodman, 1942.457
pp. 74 (ill.), 75

The Three Skulls
c. 1902/06
Watercolor over graphite, on white wove
paper, 477 x 632 mm
Mr. and Mrs. Lewis Larned Coburn
Memorial Collection, 1954.183
pp. 76 (ill.), 77

Cross, Henri Edmund
1856-1910

*Beach at Cabasson
(Plage de baigne-cul)*
1891-92
Oil on canvas, 65.3 x 92.3 cm
Bette and Neison Harris Fund, Charles H.
and Mary F. S. Worcester Collection Fund
Income, Kate L. Brewster Collection through
exchange, L. L. and A. S. Coburn Fund
Income, 1983.513
pp. 46 (det.), 47, 48 (ill.)

Degas, Edgar
1834-1917

Bathers
c. 1895/1905
Pastel and charcoal on tracing paper,
pieced and mounted on board,
1046 x 1083 mm
Gift of Nathan Cummings, 1955.495
pp. 98 (ill.), 99

Woman at Her Toilette
c. 1895/1905
Pastel on tissue paper, pieced and mounted
on sulphite board, 746 x 713 mm
Bequest of Mr. and Mrs. Martin A. Ryerson,
1937.1033
pp. 96 (ill.), 97

Ensor, James
1860-1949

Still Life with Fish and Shells
1888
Oil on canvas, 81 x 100.5 cm
Gift of Mary and Leigh Block, 1978.96
pp. 22 (ill.), 23

Gauguin, Paul
1848-1903

Old Women of Arles
1888
Oil on canvas, 73 x 92 cm
Mr. and Mrs. Lewis Larned Coburn
Memorial Collection, 1934.391
pp. 13-14, 17 (ill.)

*Portrait of a Woman in Front of
a Still Life by Cézanne*
1890
Oil on canvas, 65.3 x 54.9 cm
Joseph Winterbotham Collection, 1925.753
pp. 28 (det.), 29-30, 31 (ill.)

Ancestors of Tehamana
1893
Oil on canvas, 76.3 x 54.3 cm
Anonymous Gift, 1980.613
pp. 56 (ill.), 57

Mysterious Water (Papa Moe)
c. 1893/94
Watercolor on ivory wove paper,
355 x 255 mm
Gift of Mrs. Emily Crane Chadbourne,
1922.4797
pp. 58 (ill.), 59

Here They Love (Te Faruru)
c. 1893/95
Woodcut printed in black, ocher, and red,
on ivory Japan paper, 356 x 205 mm
Clarence Buckingham Collection, 1950.158
pp. 70, 72 (ill.)

*Day of the Gods
(Mahana No Atua)*
1894
Oil on canvas, 68.3 x 91.5 cm
Helen Birch Bartlett Memorial Collection,
1926.198
pp. 60 (ill.), 61

*Why Are You Angry?
(No Te Aha Oe Riri)*
1896
Oil on canvas, 95.3 x 130.5 cm
Mr. and Mrs. Martin A. Ryerson Collection,
1933.1119
pp. 68 (det.), 69, 71 (ill.)

*Fisherman Kneeling Beside His
Dugout Canoe*
c. 1898
Woodcut colored by hand, 205 x 137 mm
Clarence Buckingham Collection, 1971.785
pp. 70, 73 (ill.)

Tahitian Woman with Children
1901
Oil on canvas, 97.2 x 74.3 cm
Helen Birch Bartlett Memorial Collection,
1927.460
pp. 78 (ill.), 79

Gogh, Vincent van
1853-1890

Self-Portrait
c. 1886/87
Oil on canvas, 41 x 32.5 cm
Joseph Winterbotham Collection, 1954.326
pp. 8 (ill.), 9

Bedroom at Arles
1888
Oil on canvas, 73.6 x 92.3 cm
Helen Birch Bartlett Memorial Collection,
1926.417
pp. 12 (det.), 13, 16 (ill.)

Garden of the Poets
1888
Oil on canvas, 73 x 92.1 cm
Mr. and Mrs. Lewis Larned Coburn
Memorial Collection, 1933.433
pp. 18 (det.), 19, 21 (ill.)

*Corner of the Public Garden
in Arles (Tree in a Meadow)*
1888
Charcoal(?) under ink with reed pen, on
white wove paper, 493 x 613 mm
Gift of Tiffany and Margaret Blake, 1945.31
pp. 19, 20 (ill.)

The Cradler (La Berceuse)
1889
Oil on canvas, 92.7 x 73.8 cm
Helen Birch Bartlett Memorial Collection,
1926.200
pp. 14, 15 (ill.)

Hodler, Ferdinand
1853-1918

James Vibert, Sculptor
1907
Oil on canvas, 65.4 x 66.4 cm
Helen Birch Bartlett Memorial Collection,
1926.212
pp. 100 (ill.), 101

The Grand Muveran
1912
Oil on canvas, 70.8 x 95.5 cm
Helen Birch Bartlett Memorial Collection,
1926.211
pp. 102 (ill.), 103.

Lemmen, Georges
1865-1916

Portrait of the Artist's Sister
1891
Oil on canvas, 62 x 51 cm
A. A. McKay Fund, 1961.42
pp. 47, 49 (ill.)

Monet, Claude
1840-1926

Haystacks, End of Day, Autumn
1891
Oil on canvas, 65.8 x 101 cm
Mr. and Mrs. Lewis Larned Coburn
Memorial Collection, 1933.444
pp. 35, 36 (ill.)

Haystack, Thaw, Sunset
1891
Oil on canvas, 64.9 x 92.3 cm
Gift of Mr. and Mrs. Daniel C. Searle,
1983.166
pp. 35, 38 (ill.)

Haystack
1891
Oil on canvas, 65.6 x 92 cm
Martin A. Ryerson Collection, Potter Palmer
Collection, Bequest of Jerome Friedman,
Major Acquisitions Fund, Searle Family
Trust, 1983.29
pp. 35, 39 (ill.)

Haystacks, Setting Sun
1891
Oil on canvas, 65.3 x 100.4 cm
Potter Palmer Collection, 1922.431
pp. 34 (det.), 35, 37 (ill.)

Pool of Water Lilies
1900
Oil on canvas, 89.9 x 101 cm
Mr. and Mrs. Lewis Larned Coburn
Memorial Collection, 1933.441
pp. 111, 114 (ill.)

Waterloo Bridge, Gray Weather
1900
Oil on canvas, 65 x 92 cm
Gift of Mrs. Mortimer B. Harris, 1984.1173
pp. 91, 94 (ill.)

Charing Cross Bridge, London
1901
Oil on canvas, 65.4 x 92.4 cm
Mr. and Mrs. Martin A. Ryerson Collection,
1933.1150
pp. 91, 93 (ill.)

Waterloo Bridge
1903
Oil on canvas, 65.7 x 101 cm
Mr. and Mrs. Martin A. Ryerson Collection,
1933.1163
pp. 90 (det.), 91, 95 (ill.)

Houses of Parliament, Westminster
1903
Oil on canvas, 78.4 x 90.2 cm
Mr. and Mrs. Martin A. Ryerson Collection,
1933.1164
pp. 91, 92 (ill.)

Water Lilies
1906
Oil on canvas, 87.6 x 92.7 cm
Mr. and Mrs. Martin A. Ryerson Collection,
1933.1157
pp. 111-112, 115 (ill.)

Iris by the Pond
c. 1919/25
Oil on canvas, 200 x 201 cm
Art Institute Purchase Fund, 1956.1202
pp. 110 (det.), 112, 113 (ill.)

Munch, Edvard
1863-1944

Nude with Red Hair: Sin
1901
Lithograph, 777 x 480 mm
Robert A. Waller Fund, 1950.1457
pp. 80 (ill.), 81

Redon, Odilon
1840-1916

Dawn of the Last Day
c. 1880/85
Pastel, charcoal, and gouache on paper,
410 x 388 mm
Margaret Day Blake Fund, Mr. and Mrs.
Henry C. Woods Fund, and William
McCallin McKee Memorial Fund, 1982.87
pp. 51, 54 (ill.)

Woman Among Flowers
c. 1900
Pastel, on blue-gray wove paper faded
to light brown, 635 x 443 mm
Gift of Mrs. Rue W. Shaw and Mrs.
Theodora W. Brown in Memory of
Anne R. Winterbotham, 1973.512
pp. 51, 55 (ill.)

Evocation
c. 1905/10
Pastel on paper, 521 x 363 mm
Joseph Winterbotham Collection, 1954.320
pp. 50 (det.), 51-52, 53 (ill.)

Still Life: Vase with Flowers
c. 1910
Oil on cardboard, mounted on panel,
68.6 x 53.3 cm
Mr. and Mrs. Lewis Larned Coburn
Memorial Collection, 1933.450
pp. 105, 107 (ill.)

Roussel, Ker Xavier
1867-1944

Flowers
1904
Oil on panel, 75.3 x 106.1 cm
Gift of Sam Salz, 1962.484
pp. 104 (det.), 105-106, 108 (ill.)

Toulouse-Lautrec, Henri de
1864-1901

Portrait of Jeanne Wenz
1886
Oil on canvas, 80.7 x 59.5 cm
Mr. and Mrs. Lewis Larned Coburn
Memorial Collection, 1941.824
pp. 10 (ill.), 11

In the Circus Fernando:
The Ringmaster
1887-88
Oil on canvas, 100.3 x 161.3 cm
Joseph Winterbotham Collection, 1925.523
pp. 24 (det.), 25, 26 (ill.)

Moulin de la Galette
1889
Oil on canvas, 88.5 x 101.3 cm
Mr. and Mrs. Lewis Larned Coburn
Memorial Collection, 1933.458
pp. 25, 27 (ill.)

At the Moulin Rouge
c. 1894/95
Oil on canvas, 123 x 141 cm
Helen Birch Bartlett Memorial Collection,
1928.610
pp. 44 (ill.), 45, front and back covers

May Milton
1895
Oil and pastel on cardboard, 65.9 x 49.2 cm
Bequest of Kate L. Brewster, 1949.263
pp. 62 (ill.), 63

Vallotton, Félix
1865-1925

Madame Vallotton and Her Niece
Germaine Aghion
c. 1899
Oil on cardboard, 49.2 x 51.3 cm
Bequest from the Estate of Mary Runnells,
1977.606
pp. 85, 87 (ill.)

Vuillard, Edouard
1868-1940

Landscape: Window Overlooking
the Woods
1899
Oil on canvas, 249.2 x 378.5 cm
L. L. and A. S. Coburn Fund, Martha E.
Leverone Fund, Charles Norton Owen Fund,
Anonymous Restricted Gift, 1981.77
pp. 82 (ill.), 83

Child in a Room
c. 1900
Oil on cardboard, 43.8 x 57.8 cm
Mr. and Mrs. Martin A. Ryerson Collection,
1933.1180
pp. 86, 88 (ill.)

Interior with Seated Woman
c. 1904/05
Tempera and oil on cardboard, mounted
on cardboard, 44.3 x 38 cm
Charles H. and Mary F. S. Worcester
Collection, 1947.118
pp. 84 (det.), 86, 89 (ill.)

Still Life (Snowballs)
1905
Oil on cardboard, 73.7 x 64.5 cm
Gift of Mr. and Mrs. Sterling Morton, 1959.4
pp. 106, 109 (ill.)